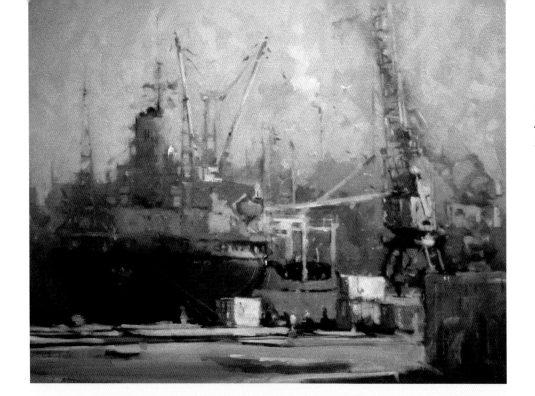

Maxwell John Wilks
Another Working Day —
Port Melbourne

a gallery of

Marine Art

Selected by Jerry McClish

First published in the United States of America by:
Quarry Books, an imprint of
Rockport Publishers, Inc.
33 Commercial Street
Gloucester, Massachusetts 01930-5089
Telephone: (978) 282-9590
Fax: (978) 283-2742

Distributed to the book trade and art trade in the United States by:
North Light Books, an imprint of
F & W Publications
1507 Dana Avenue
Cincinnati, Ohio 45207
Telephone: (800) 289-0963

Other Distribution by:
Rockport Publishers, Inc.
Gloucester, Massachusetts 01930-5089

ISBN 1-56496-418-3

10 9 8 7 6 5 4 3 2 1

Designer: Amanda Kavanagh, ARK Design / NY
Cover Image: Ben Neill, *Opposite Tacks,* project appears on page 18
Back Cover Images: top: Carlton Plummer, *Clam Diggers* (project appears on page 26); bottom: Jerry McClish, *Lifeboat*

Printed in China.

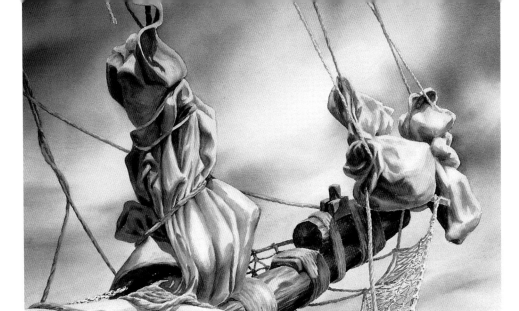

Lilian E. Parks
Bowsprit

GLOUCESTER MASSACHUSETTS

a gallery of
Marine Art

Selected by Jerry McClish

QUARRY
BOOKS

My romantic love of the sea began in the forties when I served as radio officer for the United Fruit Company line which was known as "The Great White Fleet." That experience was followed by a few years on the legendary flying boats of Pan American Airways. Now, like the majestic sailing ships of yesteryear, all remnants of that day and age are gone.

Years later, I built my own 28-foot ketch and sailed to many ports on Lake Michigan and Lake Huron. After that, I designed and built a 43-foot steel-hulled ketch—a big undertaking—that carried my wife and me down the Illinois Waterway and the Mississippi River, through the Gulf of Mexico, and on to tropical waters. We lived aboard *ONA* for many years in the Bahamas, cruising remote out-islands, and painting the scenes that Winslow Homer loved. The work, or "smack," boats that dominated the shallow banks of the Bahamas at that time are now gone. No longer are native boats built on remote beaches with natural crooks used for ribs and longleaf yellow pine used for planking. Eventually, the art of building these little vessels will be lost to time as well. Today, modern outboard boats skim over the shimmering, transparent waters at high speeds. Alas, nothing lasts forever except in our memories. I revive my own memories by putting those scenes into permanent archives—my paintings.

When I was asked to edit a book on marine painting, it was both a challenge and a chance to revive past experiences. My many friends in the International Society of Marine Painters and the American Society of Marine Artists served as a basic list of artists to be invited to submit entries. I do not know all of the participating artists personally but do feel that our association in painting the marine scene has made us all a close-knit group of friends.

Jerry McClish

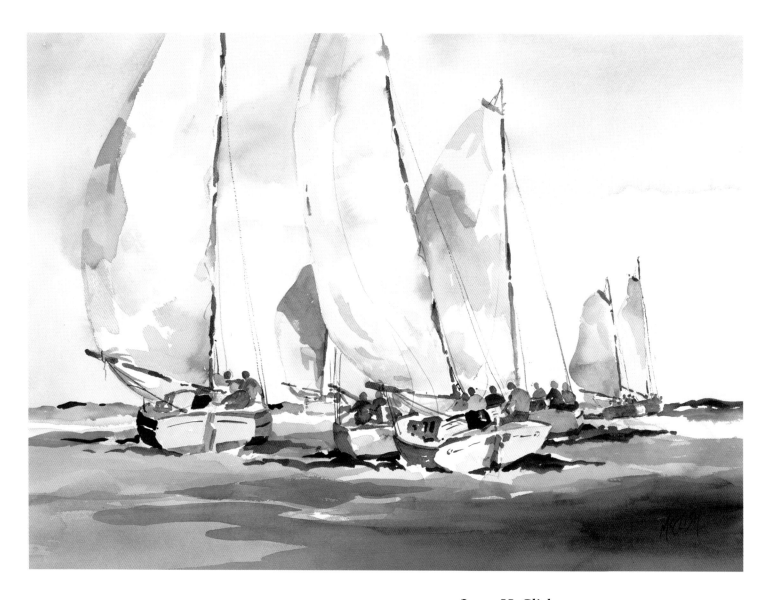

Jerry McClish

Out-island Workboat Race

Introduction

The Many Faces and Moods of the Sea

This book highlights works of marine artists who love painting the sea and its environs. As president of the International Society of Marine Painters and a marine artist myself, I am acquainted with many dedicated fine artists—many of whom are members of the organization and contributors to this book. Other participants were selected from sources such as The American Society of Marine Artists and The Royal Society of Marine Artists. I believe that these painters are some of the most talented in their field. Their art works display many different painting techniques as well as a variety of ways to present the story of the sea. Marine artwork is not strictly limited to oceans. It also includes smaller bodies of water, like inlets and bays. Leaf through this book, notice the different approaches the artists use to paint the marine scene. The colors, texture, compositions, and subject matter all relate to an artist's individual expression. By comparing different works in a spectrum of styles ranging from photo realism to representative abstract, one can become acquainted with the different personalities of each featured artist.

Waves are a moving and vibrant element in many seascapes. A boat, a ship, whether sitting at a dock or at sea, is continually in motion due to the caressing waves. Sometimes in stormy conditions, the waves swell menacingly and angrily batter the vessels or the shoreline, making obvious their power over anything that dares to trespass near or on the surface of the sea. The strength of giant waves is awesome and their behavior fickle. They can tear massive blocks of quarry from neatly built seawalls and toss them like pebbles to be deposited elsewhere in a mixed up jumble. They can alter the shapes of beaches in a matter of hours. But soon after the storm subsides, the waves quickly revert to gentle murmurs as they playfully dissolve on sandy beaches.

Witnessing the power of waves at sea or splashing on rocky shores is exciting to the marine artist. Accompanying skies enhance the romance of the picture, complementing the moods of the ocean. A stormy sky and an angry sea are close partners. Conversely, a serene sky and a calm harbor can beautifully reflect vessels and shore structures. J. M. W. Turner uses vibrant colors and somewhat abstract presentation in his paintings of the sea. Winslow Homer's oil and watercolor paintings display the range of the sea's moods. His paintings of the deep blue waters of the Gulf Stream, with their incipient dangers, contrast to his watercolors of the shallow, translucent waters of the Bahamas, the natives, and their workboats,.

Harry Ballinger is a splendid example of an artist who loved the sea. His book, *Painting Sea and Shore* is a classic. Ballinger was in his late nineties when I had the privilege of meeting him. Sitting in his cottage by the sea in Rockport, Massachusetts, we had many conversations on his modest and informative approach to painting the nautical scene.

In contrast to sea craft built before the turn of the century, modern seagoing vessels are mainly functional in their design. Around 1950, the hulls of new cargo ships began to be designed to efficiently handle freight without regard to their looks. Having abandoned the graceful lines of similar ships built in the past, these vessels have lost a portion of the aesthetic allure for artists and mariners alike. Even new passenger liners bulge with maximum accommodations. Gone are the spacious open areas lined with traditional deck chairs. Deck structures have become characterless, unadorned boxes; they seem to have lost a bit of the spirit of the sea.

Older, traditional vessels are favorite subjects for most artists, including myself. Nostalgic thoughts of the seas of the past invoke images of primitive boats and ships, the waterways of long-ago Venice, and even ancient warships—the clumsy, blunt-bowed, wind-powered men-of-war engaged in colorful battle scenes. Through the years, artists have painted ever-changing versions of the sea and ships that sailed upon them. Every type of vessel: square-rigged clipper ships, whalers, trading schooners, and even small pleasure boats; has served as a subject for marine painting. An example of this can be found in Captain Joshua Slocum's epic book, *Sailing Alone Around the World*, in which the yawl *Spray*, a 36-foot classic vessel, commands a fair amount of aesthetic admiration.

When I'm starting a painting, even simple thoughts of the sea (the rollicking waves, dock scenes, reflections in rippled water, a scene of the vessels that ply the oceans) create excitement in my studio. Just thinking about the ocean conjures romantic visions of seagoing voyages with ships combating stormy waves or drifting on windless seas and sets the brush to work capturing all the details. The nautical scenes painted by artists in this book are representative of the aspects of the sea that I find so vibrant and engaging. Experience the spirit of the sea and all that surrounds it as you page through this book. Have fun interpreting the feelings of the artists who created the artwork.

Jerry McClish

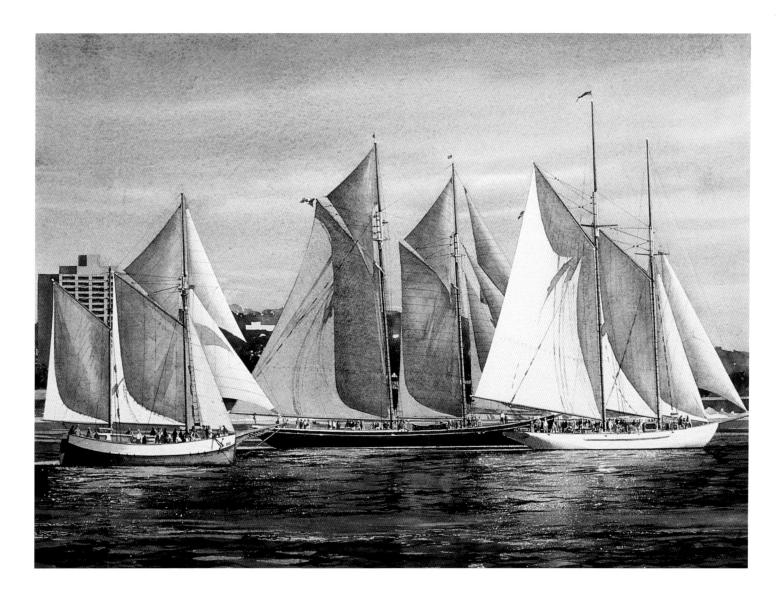

A. William Rouzie

Schooner Race

20.25" x 28" (51 cm x 71 cm)
Watercolor on Arches 300 lb. cold press paper

Sailing buffs flock to Victoria, Canada, to see the annual classic boat show with its featured schooner race off the Pacific coast. Here, historic vessels, gathered for the race, pass by and are reviewed by the committee boat. On the right is the schooner *Adventuress*, with its white hull contrasting against the black hull of the schooner *Robertson II*. At left is the gaff-rigged ketch *Duen*, built in Norway in 1939 and now used as a charter vessel. This cloud of sail underlined with graceful hulls on sparkling water is a rare sight and worthy of recording. My intent was to capture the mood of the moment and the crowded, overlapping sails without losing the distinctive character of each vessel.

Charles Vickery

Rough Sea Coast

24" x 36" (61 cm x 91 cm)
Oil on canvas

The beauty of the sea is a limitless allure. I enjoy the drama that is awesome with its majestic and great power. Painting this scene of rough sea coast with its crashing waves was most inspiring.

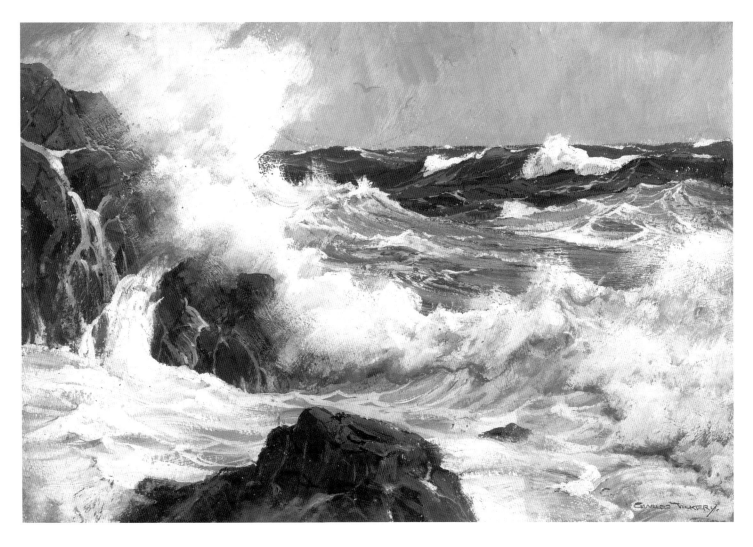

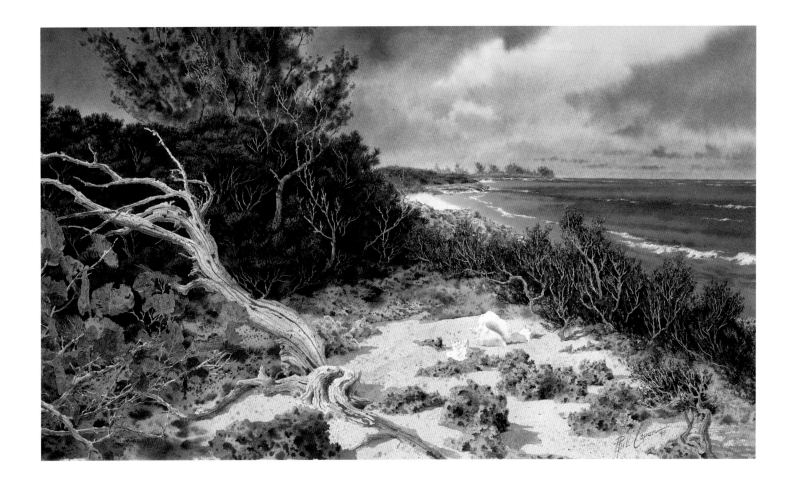

Phil Capen

Windward Shore
16.5" x 29" (42 cm x 74 cm)
Watercolor on Arches 300 lb. rough watercolor paper

~~~~~~~~~~~~~~~~~~~~

Several miles south of where I live on Green Turtle Cay, in the Abacos, Bahamas, lies an uninhabited cay with an extremely rough windward side. It is a dangerous lee shore for sailors. Wind and salt spray have shaped trees and shrubs into lovely sculptures. Sand and eroded catalytic limestone add their textures to this scene. This is a studio painting composed from sketches, photos, and memory. After sketching and before painting, I cover, with liquid masking, any details which are lighter than the sky or water. This gives me more freedom to paint the background on damp paper. Using this technique, I am able to achieve soft and distant edges to the clouds.

## Margaret S. McCrea

### *Lost in Dreams*
22" x 15" (56 cm x 38 cm)
Watercolor on Arches 140 lb. cold press paper

~~~~~~~~~~~~~~~~~~~~

The marine paintings I make deal with the places where land meets water and what happens in those areas. The haunting image depicted in *Lost in Dreams* made an impression that will be with me for a lifetime. The scene was observed on São Vicente, a small island in the Cape Verde Islands in the Atlantic Ocean. The little girls were playing at the seashore and I wondered about their lives and their play. Tiny sand particles blocking the sun's rays created an unusual, almost eerie, atmospheric condition. Many island inhabitants were at the waterfront mending fishing nets, working on their boats, playing games, or just staring into the sea.

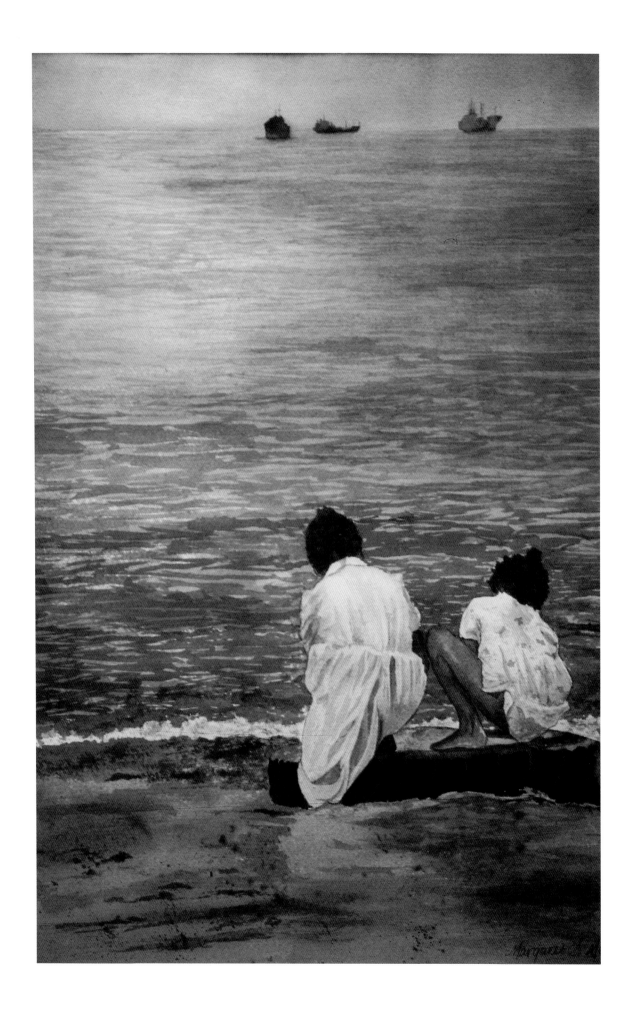

Anthony R. Thompson

The Boats
8" x 10" (20 cm x 25 cm)
Oil on prepared Masonite panel

This is a view of Monhegan Island in Maine, looking past the harbor and Manana Island towards the southwest. Everywhere one looks on Monhegan, there is a painting. The strong shadows and shapes afforded by the buildings and boats pulled up on the beach, the color contrasts, and the stark simplicity of Manana Island, all combined to lead me to paint this scene. The small size chosen for this involved composition was a welcome challenge.

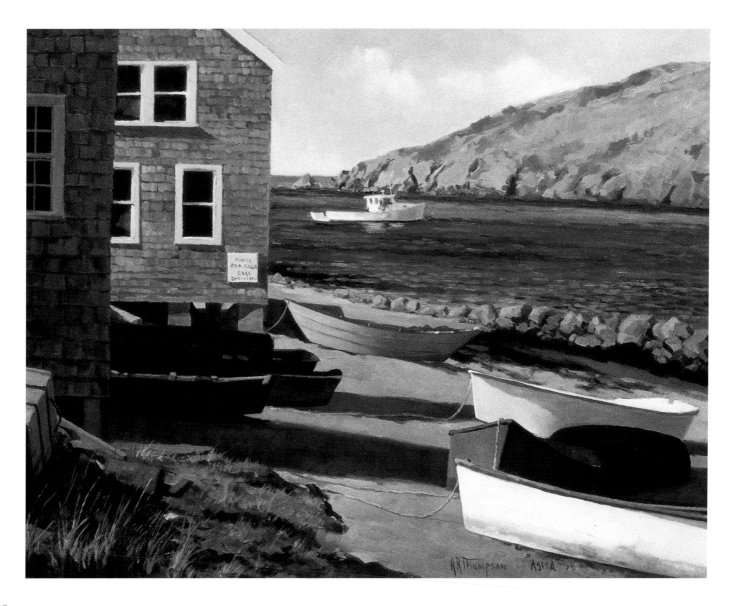

Carolyn Councell

Fitting Out

16" x 22" (41 cm x 56 cm)
Watercolor on Arches 140 lb. cold press paper

Fitting Out was inspired by the shapes, color, and interesting activity grouped together in this busy scene from Cape Ann, Massachusetts. I felt compelled to paint this subject and explore all it had to offer. About three-quarters of the painting was done on location. I find that being there with the people, weather, and other elements allows me to put more feeling into the picture.

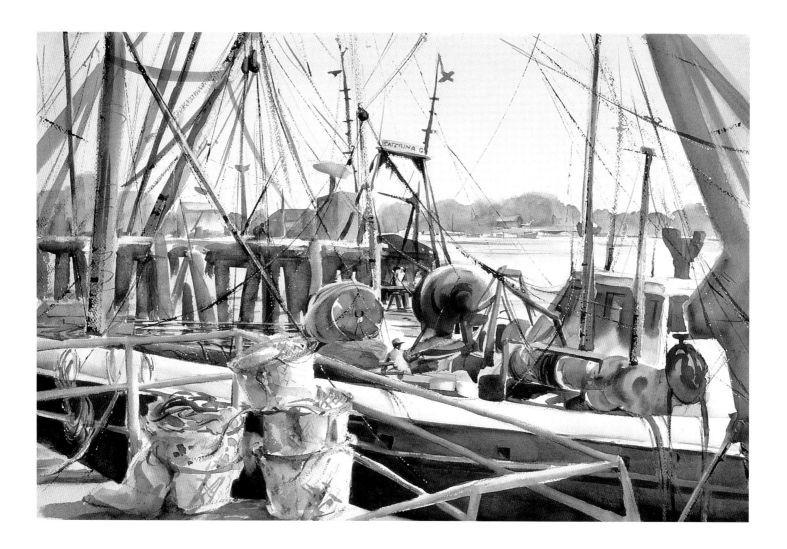

Dimetrious Athas

Cat Race, Padnaram, August 1955
24" x 36" (61 cm x 91 cm)
Oil on gesso board

For the past few years, I've found myself drawn to recording sailing races of all types of vessels for pictorial history. For this scene, I was positioned on the famous catboat *Simba*, which was in the lead until the third mark when she came about too hard and ripped her sail. As we watched the *Shoveller* and *Molly Rose* pass by, I was inspired to capture the scene. The sky was painted to depict late afternoon and the other catboat was included to create visual interest. Many glazes were applied to achieve luminosity. By painting on gesso board, I'm able to etch the rigging lines on the board so there is no worry of redrawing them after the background is laid in. Using this technique, one must be careful to avoid scratching in unwanted lines, as they are impossible to correct.

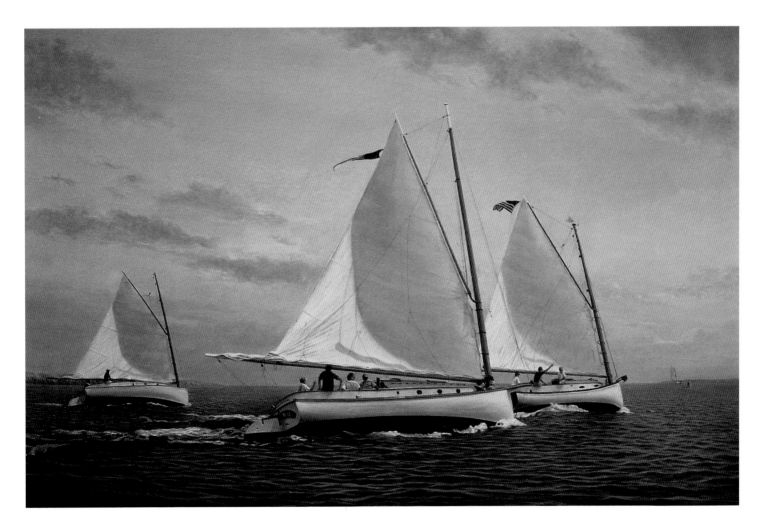

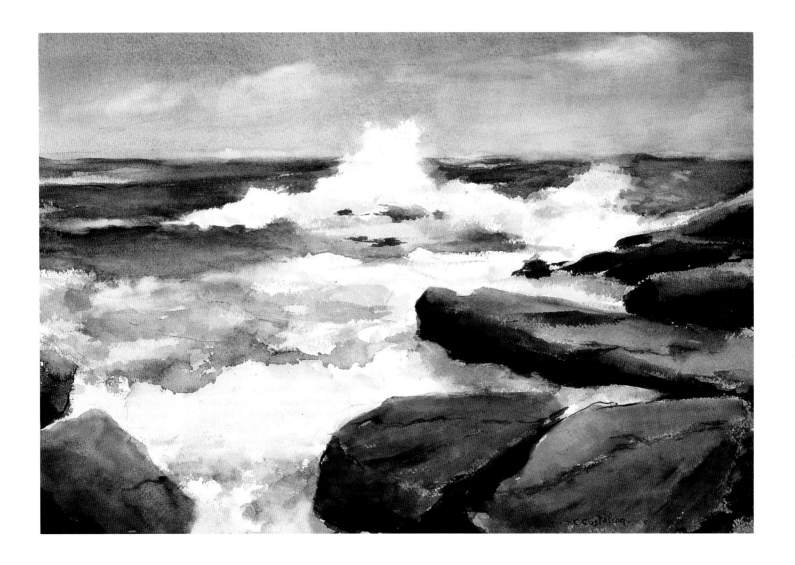

Carl Gustafson

Andrews Point
14.5" x 22" (37 cm x 56 cm)
Watercolor on Arches 140 lb. rough paper

As a resident of Rockport, Massachusetts, I find the seacoast almost unlimited in subject matter for an artist. This Cape Ann watercolor was painted on location with a minor touch-up back in the studio. The ever changing weather moods along the New England coast seem to be an attraction for artists. Most of my seascapes have been done along the Cape Ann shore and coastal Maine.

Donald A. Mosher

Drying Sails, Old Harbor

36" x 48" (91 cm x 122 cm)
Oil on linen canvas

I love to paint on Cape Ann, Massachusetts where there is a special light. This picture depicts the harbor at Gloucester, Massachusetts, in the thirties or forties when the old schooners were kings of the fishing industry. Every five to ten years the harbor freezes over and makes interesting patterns on the water. Although it is winter, I feel a warmth in this oil painting.

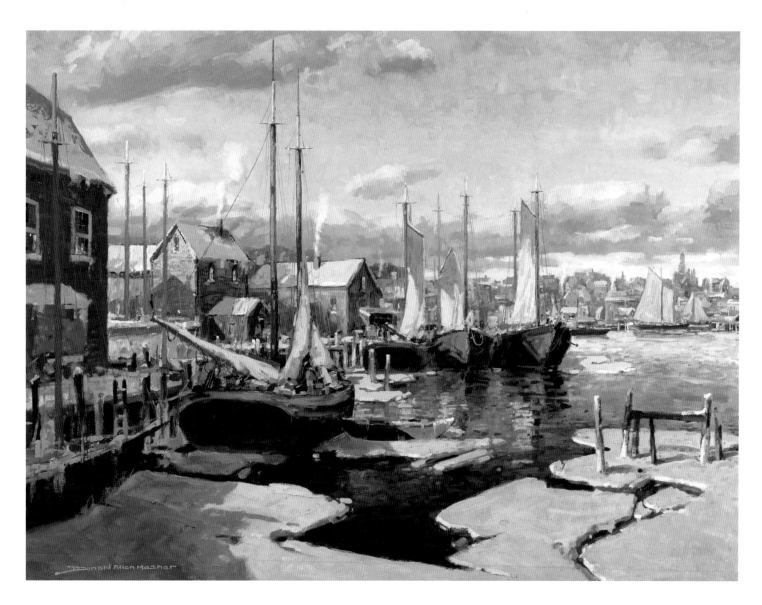

Dutch Mostert

Perfect Day's End
13.5" x 19.5" (34 cm x 50 cm)
Transparent watercolor on Arches 300 lb. rough watercolor paper

This is the first in a series of paintings of the colorful old rowboats that belong to the Center for Wooden Boats in Seattle, Washington. Even though the painting is done in transparent watercolor, I build up my color to a very solid consistency by applying wash after wash of color to obtain an image that incorporates the best of transparent and opaque watercolor techniques. By choosing fairly simple subject matter, I am able to concentrate on other basics like color and composition. I am also experimenting with different types of light to enhance color and shadows. This creates a variety of moods and makes a relatively simple scene more interesting.

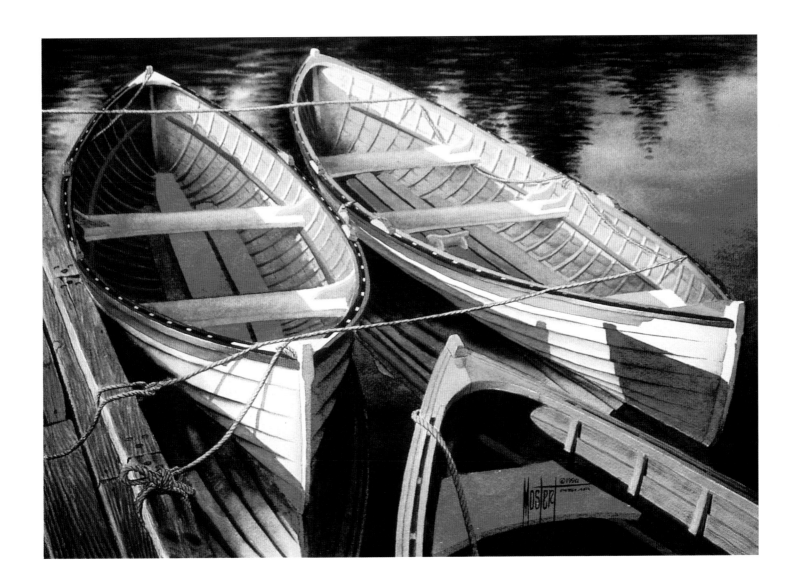

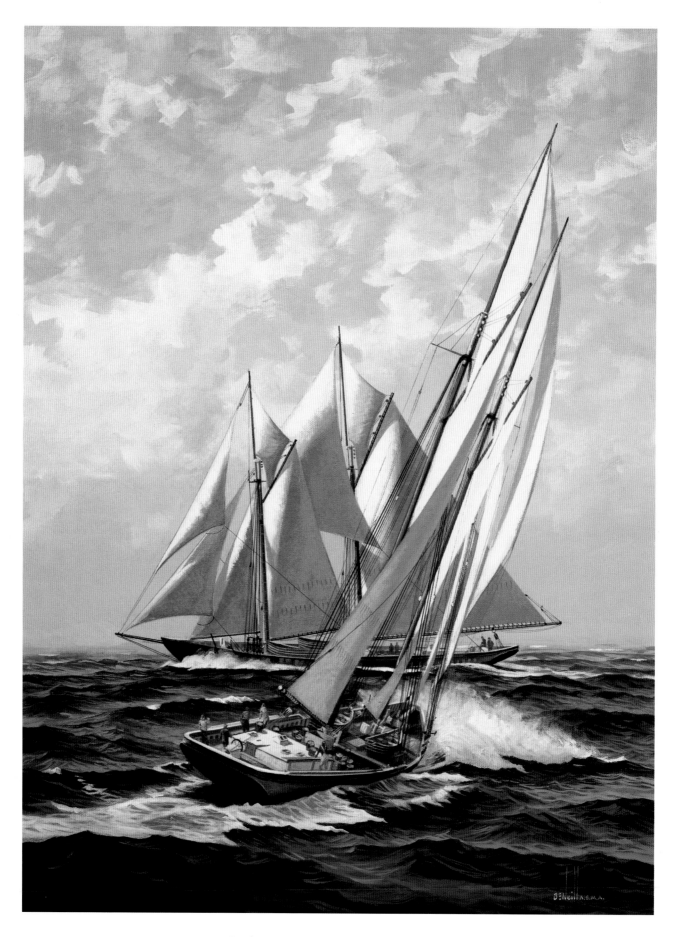

Ben Neill

Opposite Tacks
24" x 18" (61 cm x 46 cm)
Acrylic on canvas

~~~~~~~~~~~~~~~

The race is on! Two fishing schooners with full holds race each other from the fishing banks to home port. Crew members know that the fastest ship with the most skillful skipper will earn them bragging rights and the highest price for their catch. Ben Neill's fascination and knowledge of the sea began when, as a youth, he sailed the waters of Massachusetts Bay and was surrounded by the grace and beauty of coastal and fishing schooners. His studio on Cape Cod, Massachusetts is an ideal location for him to research and then create scenes on canvas depicting the romance and history of the sailing vessels that plied the Atlantic Coast from the 1700s to the early 1930s.

## Charles Raskob Robinson

### *Lorraine Rose*
18" x 27" (46 cm x 69 cm)
Oil on canvas

~~~~~~~~~~~~~~~

Chesapeake Bay subjects have long attracted this artist, especially the vessels and "watermen" of the Eastern shore of Maryland. While sketching in Knapp's Narrows, the narrow channel of water separating Tilghman Island from the Maryland mainland, I encountered the skipjack, Lorraine Rose, which had served out its working days. Evidence of its hard life is depicted here in the soft early-morning light.

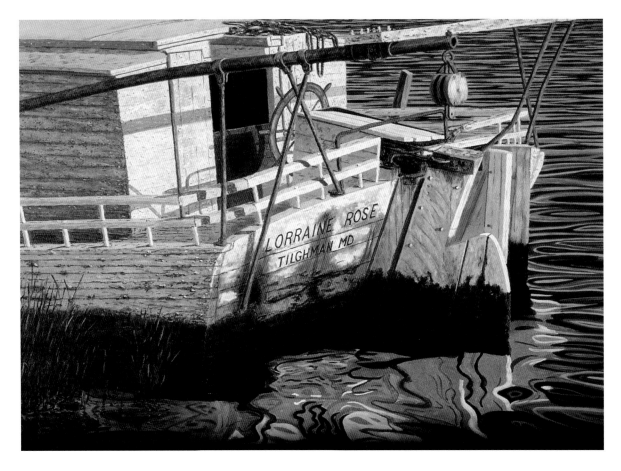

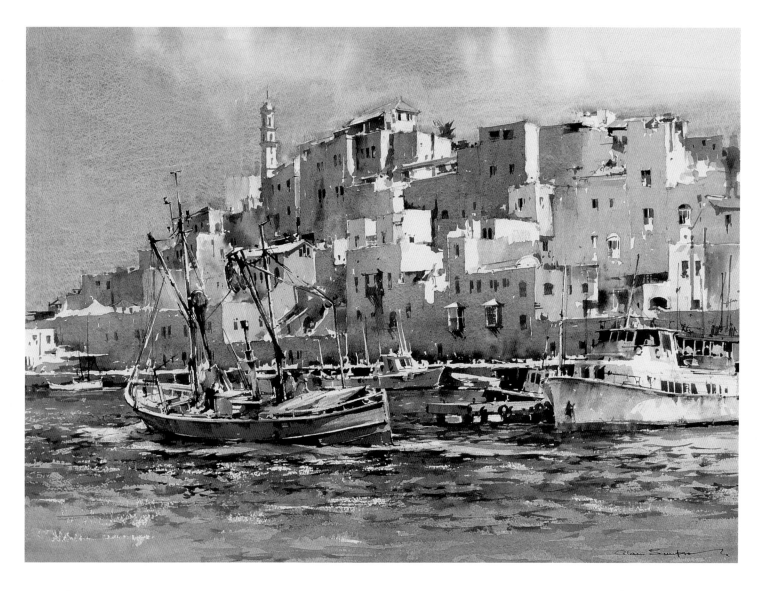

Alan Simpson

Out of Jaffa

21.5" x 29.5" (55 cm x 75 cm)
Watercolor on Bockingford 250 lb. paper

The magical seaport of Jaffa, Israel, carved out of stone over many centuries, dappled with warm morning sunlight, towers majestically above the sparkling waters of the harbor. It is a wonderful but complicated scene. The view of the town, massed with warm stone dwellings, was painted in two stages. Applying bright warm but varied stone colors across the whole area created a strong impression of sunlight. After this dried, the shadows were painted in, allowing the shadow of one building to merge into the shadow of another to create larger light and dark patterns. The sea was painted in several layers. Dragging the brush created texture and the suggestion of movement. Some of the colors used in the stone buildings above were echoed in the sea so that the two parts link together. The fishing boat was given strength of color and only essential detail was used. A jaunty angle suggests speed and movement and the vessel takes its place as the main point of interest.

Wini Long

Frolicking Surf
24" x 30" (61 cm x 76 cm)
Watercolor on Arches 140 lb. cold press paper

Living in Maine near the coast each summer, I can observe, feel, and walk amidst the surf. The rushing and stormy surf inspires me most. Using watercolor, I can express my feelings for the restless sea. Rock formations are mind boggling, never looking the same. I am fortunate to have the ocean so close that I can paint it and reflect its many moods.

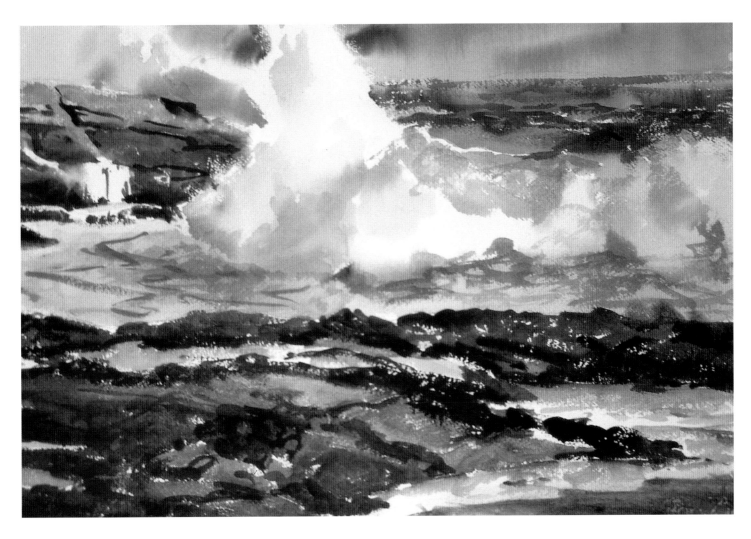

Catherine Gill

Fisherman's Terminal, Seattle
16" x 20" (41 cm x 51 cm)
Oil on canvas with gesso

This historic area of Seattle is a marine painter's dream. There are hundreds of fishing boats, many belonging to local Washington fishermen. Others docked here may be awaiting repairs before returning to the fishing waters of southeast Alaska. Painting on location here is filled with noise, energy, colors, and motion. Fisherman's Terminal is located on the west end of the ship canal connecting Puget Sound and Lake Union. I try to set up in the morning in order to get a few hours of fairly consistent light. A second day on location is usually needed, with the hope that the boat hasn't left, to finish the painting in the same light.

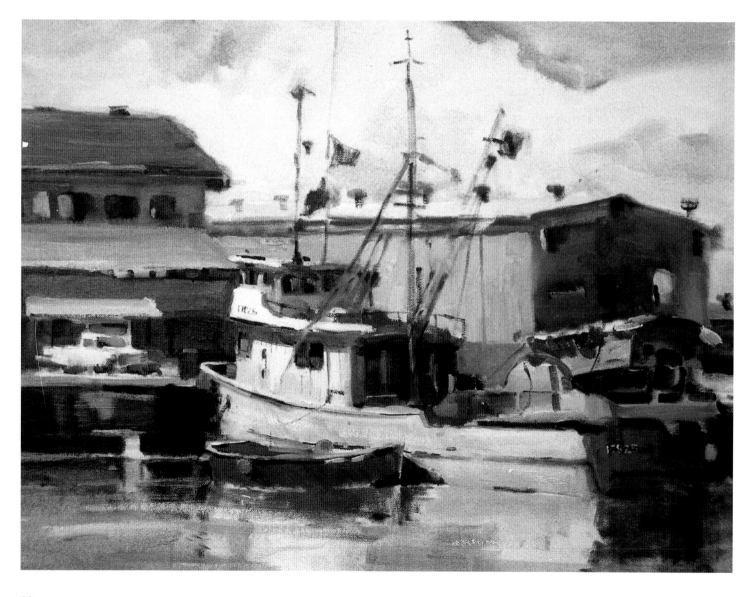

Walt Gonske

The Bridge of Sighs
22" x 29" (56 cm x 74 cm)
Watercolor on Arches 300 lb. hot press paper

Venice is such a wonderful place of timeless architecture built along a maze of canals. There are compositions for paintings everywhere and all within an area of roughly two square miles (5.2 square kilometers). John Singer Sargeant painted this view of the Bridge of Sighs one hundred years ago, and it is very much the same now as then. I just had to paint it myself.

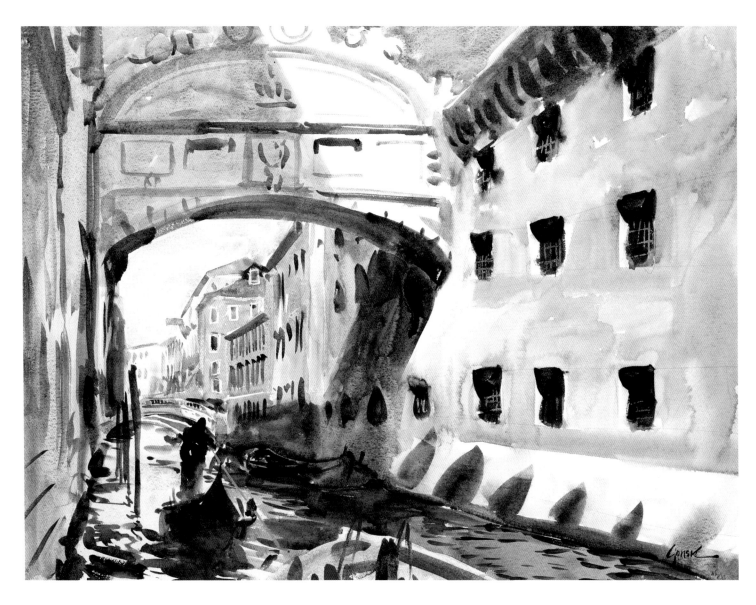

Capt. M. E. Casey Whitten

Bridges are America's Cathedrals
22" x 30" (56 cm x 76 cm)
Watercolor, gesso, gouache on Arches 300 lb. cold press paper

A lifelong fascination with boats and marine activities led me to do a series of watercolors depicting the New Roosevelt Bridge in Stuart, Florida. While boating, my husband and I captured many interesting photos during the construction of the bridge. This is one of our favorites. From under the bridge, the sight was awesome. It reminded me of a great cathedral. I overlaid the smokestacks with gesso and covered them with gouache, which created a special texture.

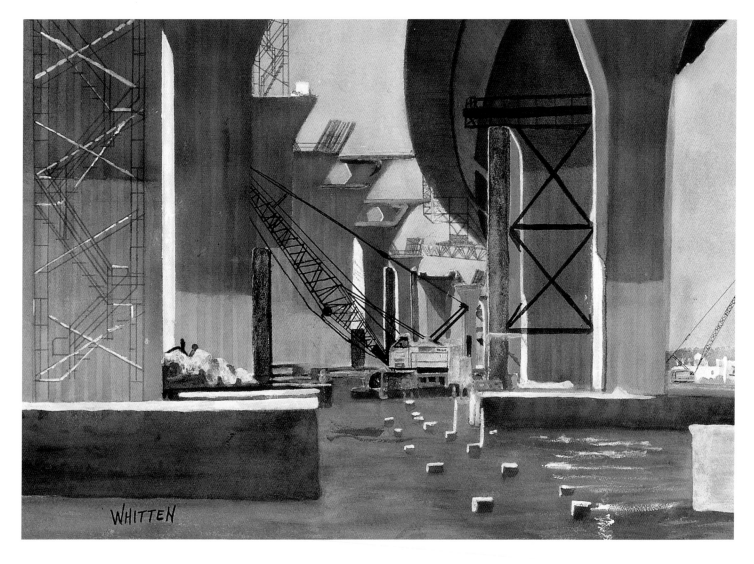

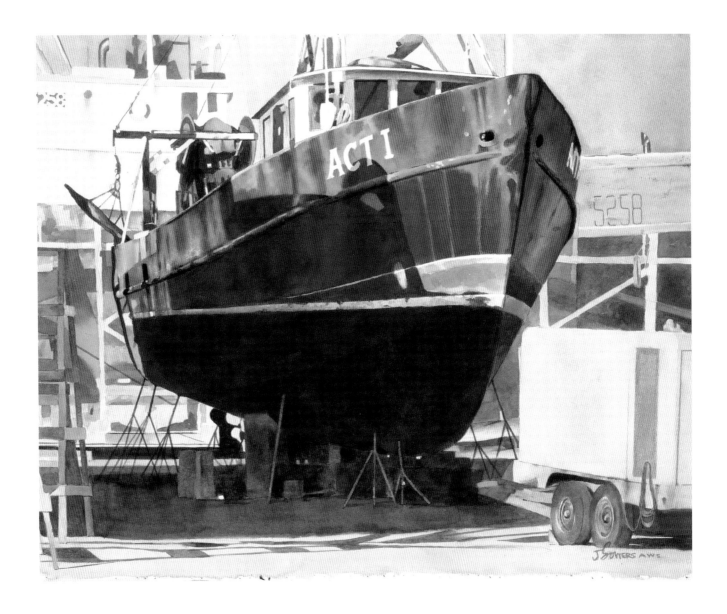

John Sowers

Act 1

22" x 30" (56 cm x 76 cm)
Watercolor on Arches 140 lb. cold press paper

This transparent watercolor was inspired by the large dominant shape of a ship in dry dock at the Fairhaven Boat Yard across the river from New Bedford, Massachusetts. The large abstract shape of the hull was painted in the warm afternoon sun with oranges and reds which are in contrast with the deep red and blue shadows. Detail was eliminated or simplified in the background surrounding the ships. I am always interested in the shapes and colors that I see in marinas and boat yards. There is an endless source of design possibilities in these locales.

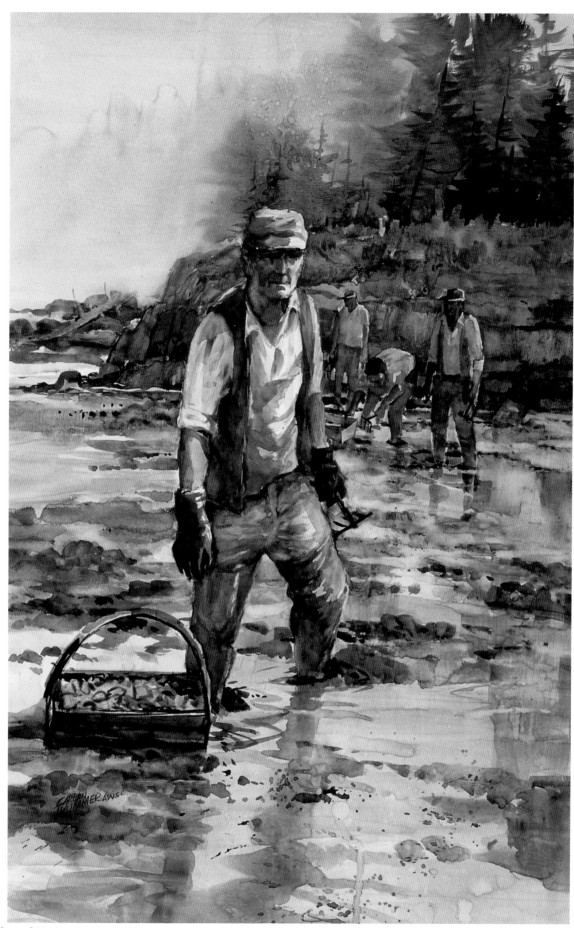

Carlton Plummer

Clam Diggers
30" x 20" (76 cm x 51 cm)
Watercolor, gouache, and gesso on Strathmore regular surface illustration board

Clam Diggers was painted to show a spatial relationship of figures to their environment. Lighting and reflections, so often involved with coastal clam flats, were also a major consideration. I created the figures mostly from imagination but past photos and drawings helped me with the various positions. The figures in the background echo the main figure but remain in the distance. Other shapes were painted to help tie the painting together and to force the vertical feeling. Much of the painting was started quite wet-in-wet with wet-in-dry glazing later on.

Cynthia Eastman-Roan

The Net IV
22" x 33.5" (56 cm x 85 cm)
Watercolor, water media on Arches 130 lb watercolor paper

This is from a series of solar paintings. I am exploring new techniques in watercolor using watercolor and other opaque media. The net folding in and around the shells gave me a feeling of the sea and seashore.

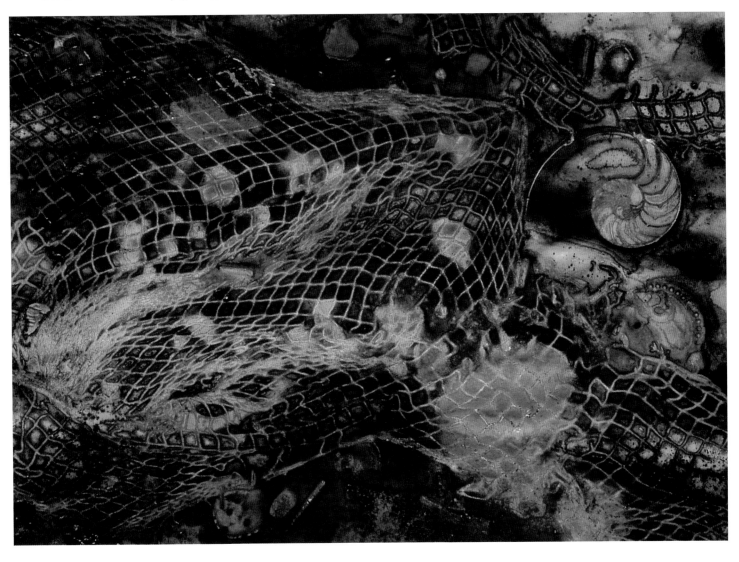

Michael B. Karas

The Maine Coast

30" x 40" (76 cm x 102 cm)
Oil on linen canvas

I have always been attracted to the sea, a subject that affords me endless possibilities of design elements and color relationships. Particularly challenging is the combining of these elements to form a harmonious whole that expresses fully the various moods of the sea. Living on the coast of Maine, I am in close proximity to my subject matter, whether it be bold rocky coastline, sweeping sand beaches, or peaceful coves and harbors. Much of my work depicts impressions or feelings rather than photographic representations. It is the essence of the subject that I am after. Creating the illusion of detail without actually painting it is what I find most inspiring as a painter.

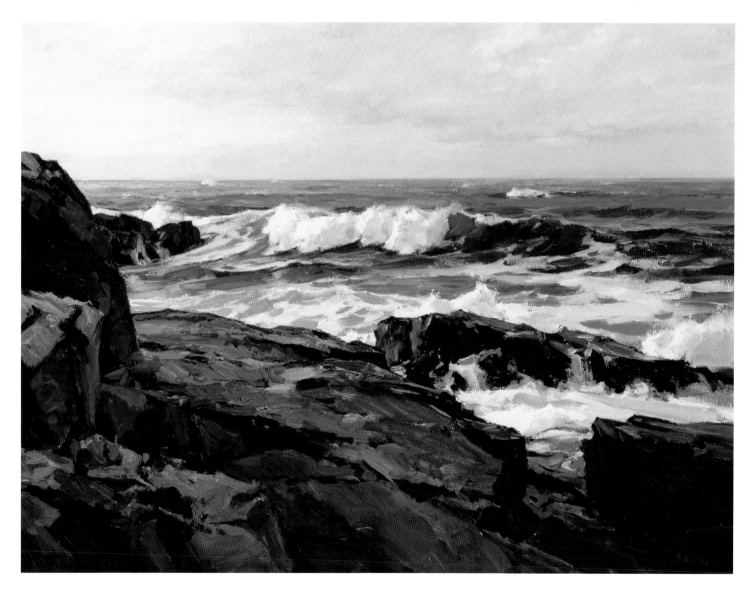

Charles Laskey

Hopetown Lighthouse — Bahamas
24" x 30" (61 cm x 76 cm)
Watercolor on Arches 140 lb. paper

I enjoy painting lighthouses and other marine structures. Over the years, I have painted many of these sentinels, including those at Jupiter and St. Augustine, Florida; Barnegat, New Jersey, and others.

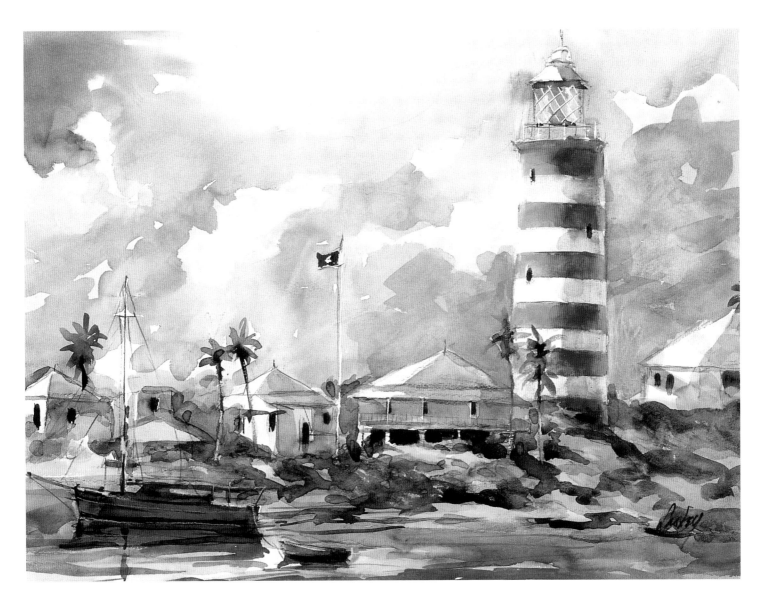

William C. Kavanek

Skiff at St. Michaels
12" x 18" (30 cm x 46 cm)
Oil on board

One can easily get the feeling that if these little skiffs could grow up, they would be skipjacks! At first, this painting was a pretty view of the Chesapeake Bay shoreline at St. Michaels, Maryland, but I find it difficult to do a scene of nature without the human element somewhere. The waves pounding the Maine coast are not as interesting as when someone is watching. The giant redwoods in the Pacific Northwest make a lovely landscape, but their incredible enormity is not apparent until there is a tiny human figure standing by. With this in mind, I painted in the fisherman who has been crabbing in his handsome little skiff. He is now busy enhancing the shoreline.

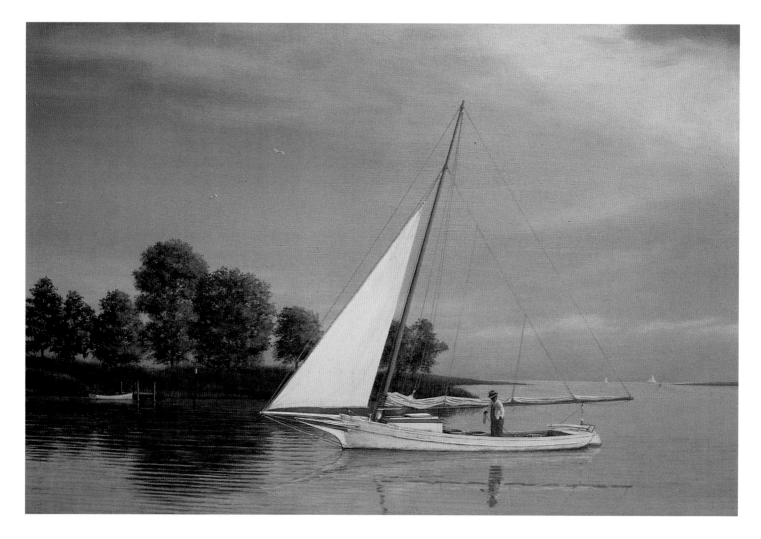

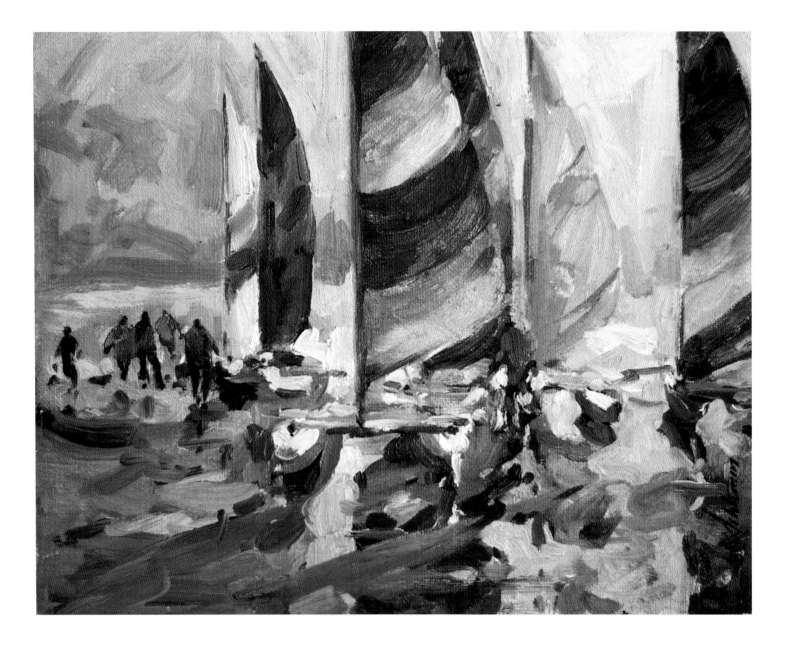

Betty Lou Schlemm

Lunch Stop — Long Beach
9" x 12" (23 cm x 30 cm)
Oil on Masonite with gesso

Every year, the "Hobies" have a day-long sail and lunch at Long Beach, in Rockport, Massachusetts. Many of us wait on shore just to see them sail in and beach their boats. I was back on the beach sitting on the sand as I painted this in my 9" x 12" English pochade box. It was finished at home. The event is always a very exciting time for both the sailors and onlookers. Stand oil and damar varnish were added to the mostly turpentine medium to create this picture.

Stanley Wayman

Huddle Up

7" x 19" (18 cm x 48 cm)
Watercolor on Strathmore cold press watercolor board

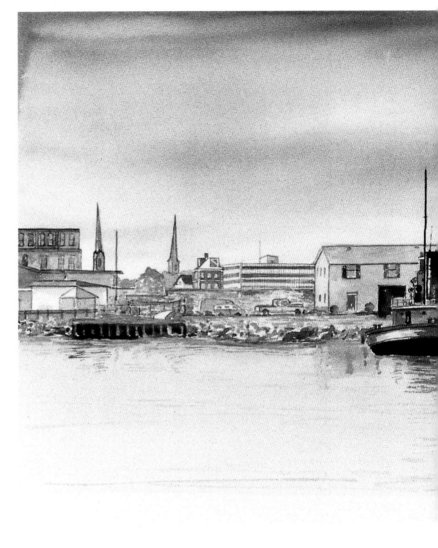

For months after the recent war in the Middle East, American ships sailed into port and were aided by tugs as they headed for the Charleston Naval Base in South Carolina. On their decks were large tanks and vehicles, captured and claimed as prizes or perhaps just grim reminders of the perils of war. My desire was to witness this close up. For a week, I became an interested observer as the powerful tugs muscled huge ships many times their size into berths. When idle, the tugs would be snuggled up side-by-side at their home piers. The analogy was evident. The name of this painting, *Huddle Up* seems most appropriate.

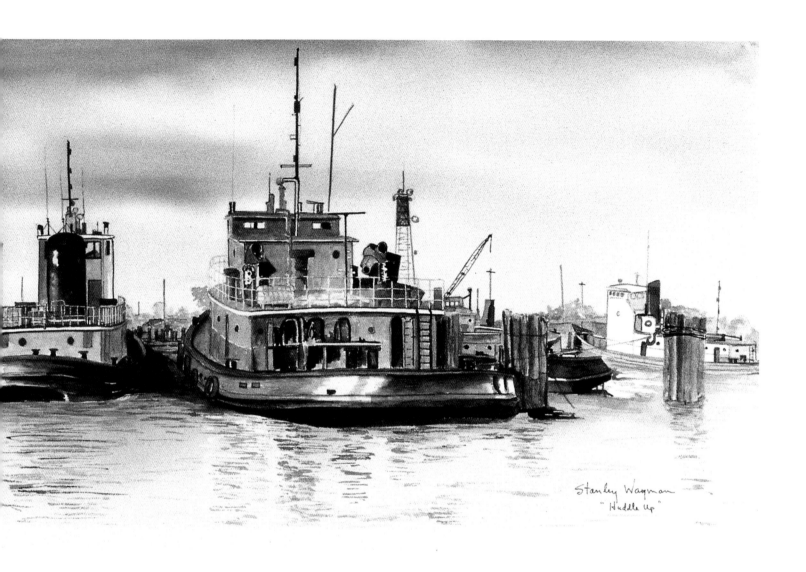

Stanley Wayman
"Huddle Up"

Wanda Coady

Barrier Reef
22" x 36" (56 cm x 91 cm)
Watercolor on Arches 140 lb. cold press paper

A day of snorkeling over Australia's Great Barrier Reef inspired this painting. The number of colorful fish swimming around, ignoring our invasion of their territory, seemed to indicate that life under the surface relates to the sea as much as scenes above water do.

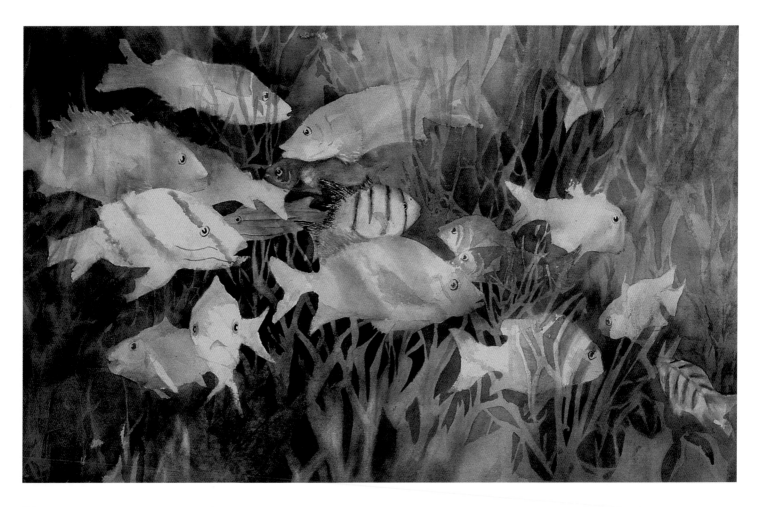

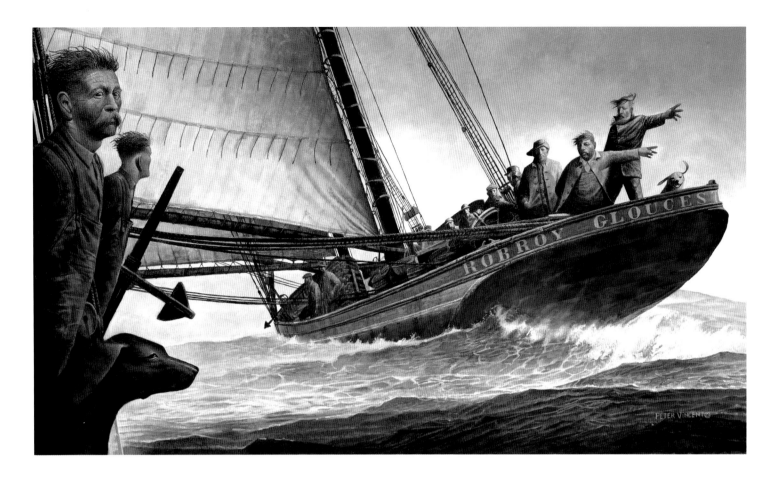

Peter Vincent

Georges Men

23" x 40" (58 cm x 102 cm)
Acrylic on Masonite

I like painting historic scenes of the fishing industry in Gloucester, Massachusetts, at the turn of the century. Inspiration comes from local history and my family's long-standing tradition of seafaring. My style of painting incorporates a strong human element into marine art.

Thomas A. Nicholas

Mid-Winter Thaw
36" x 36" (91 cm x 91 cm)
Oil with claussens medium on linen canvas

As composition is my paramount concern in painting, more often than not I rearrange nature to suit my needs. In this painting of Gloucester Harbor, in Massachusetts, parts of the subject exist and others do not. Billowing cumulus clouds and late afternoon winter light create a dramatic mood.

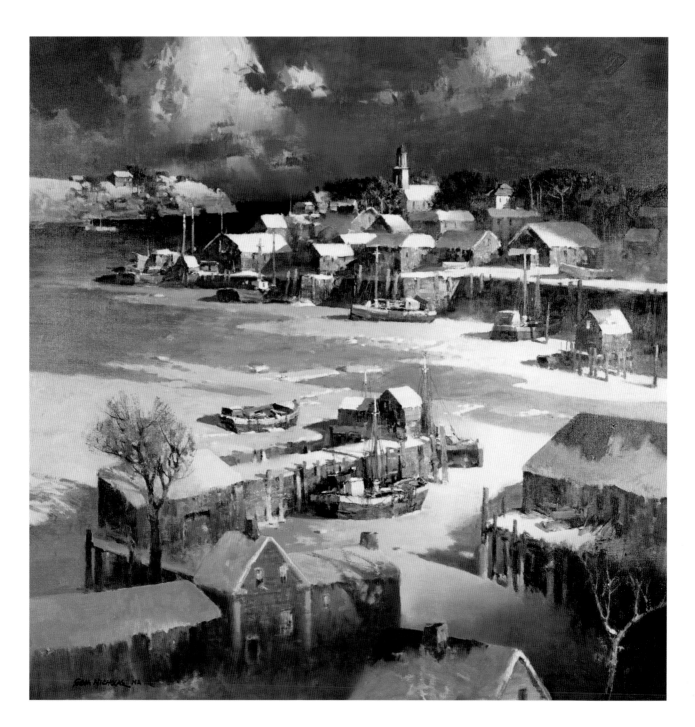

Donald R. Carmichael

La Push — Olympic Peninsula, WA
26.5" x 39.5" (67 cm x 100 cm)
Watercolor on Strathmore hot press illustration board

I return to the Pacific Northwest coastal regions each summer for inspiration. The Olympic Peninsula in Washington provides ample visual material for subject matter. I especially enjoy the coastal rocks and the ever changing tidal pools.

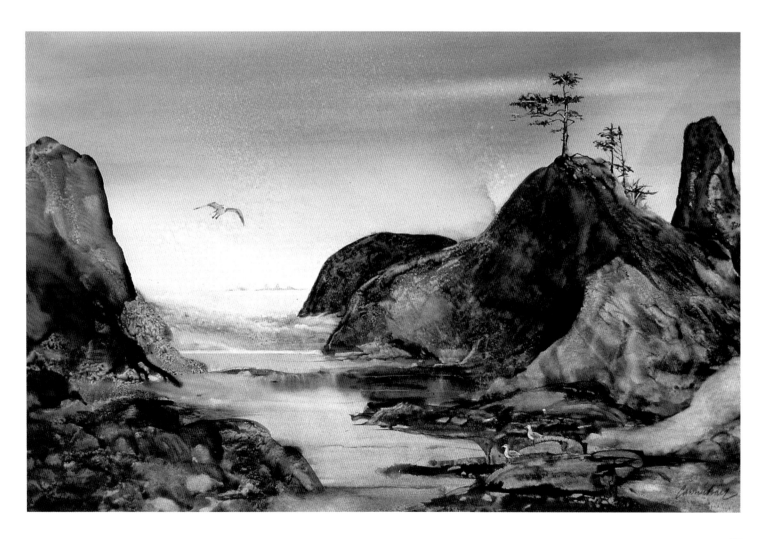

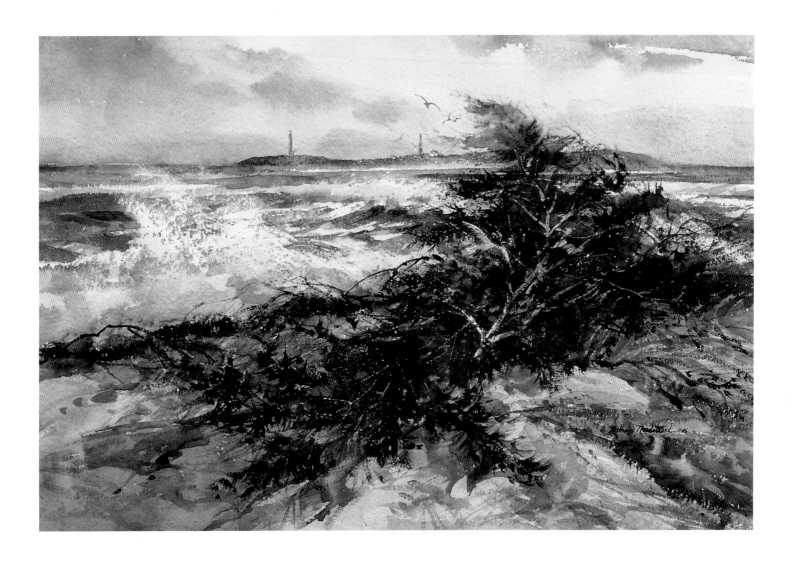

Nathalie J. Nordstrand

Offshore Winds
18" x 26" (46 cm x 66 cm)
Watercolor on Fabriano Esportazione 300 lb. rough paper

This is an October scene from my home in Rockport, Massachusetts, looking toward Thatcher Island in the distance and the colorful windswept shore nearby. The two views are compelling and beg to be painted. I found the feeling of movement and wind could be emphasized by painting through rubber cement boldly applied then rubbed away.

Patricia Wygant

Grand Manan Fish Houses and Smoke Houses
10.5" x 13.5" (27 cm x 34 cm)
Watercolor on Arches 300 lb. cold press paper

This work is a composite of typical buildings in Seal Cove, one of the villages on Grand Manan Island, New Brunswick, Canada. The painting is an attempt to convey the feeling that everyone there has a direct connection to the sea through lobstering, fishing, or curing smoked herring.

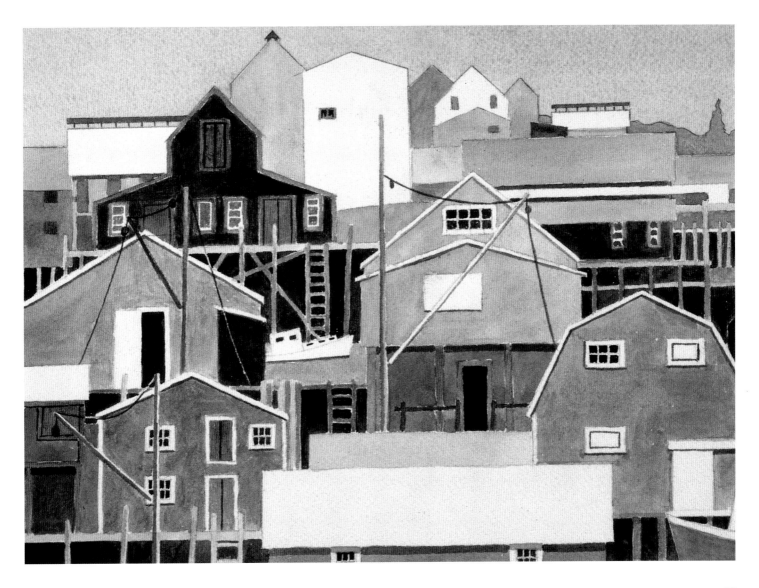

Robert C. Semler

Twilight on the Delaware
24" x 36" (61 cm x 91 cm)
Oil on linen canvas

This painting depicts a scene circa 1912, looking over the Pennsylvania-Reading Railroad Ferry Terminal toward Camden, New Jersey. The Wilson Line steamer *Twilight* passes the ferry slips heading north on a moonlit night. This type of historical painting requires many hours of research, sometimes taking more time than the actual painting process.

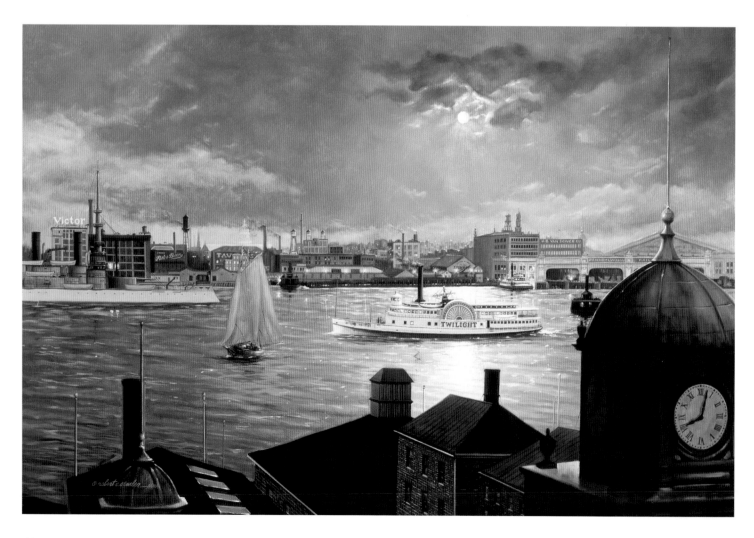

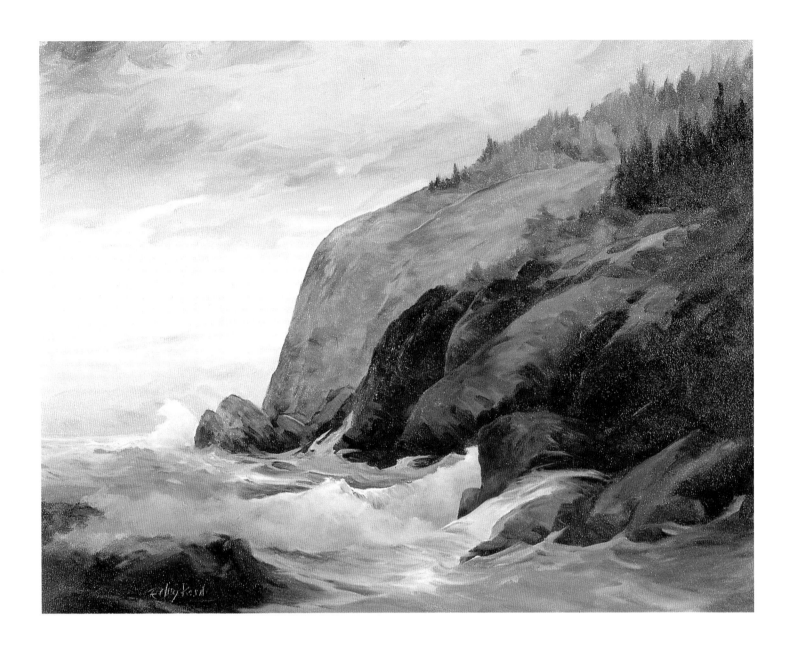

R. Clay Kent

Blackhead, Monhegan
22" x 28" (56 cm x 71 cm)
Oil on canvas

We love the sea and allow its potent power to engulf our emotions, thoughts, and passion.

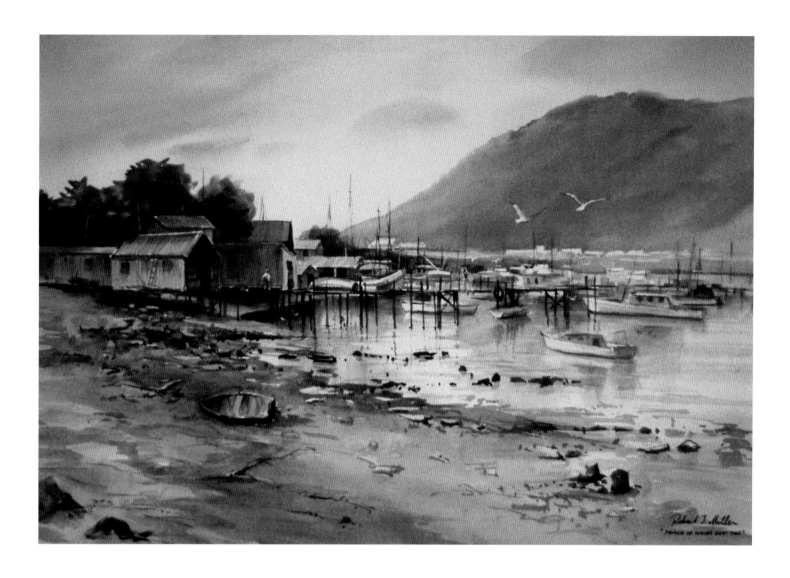

Robert T. Miller

Prince of Wales Bay
13" x 20" (34 cm x 51 cm)
Watercolor and acrylic on Winsor & Newton 140 lb. watercolor paper mounted

Prince of Wales Bay is located in Tasmania near Hobart. This subject was painted in my studio using sketches and slides. I found the contrasting elements very interesting. The broad stretch of water, the background mountain, and the bright sky beautifully complemented and supported the fishermen's sheds and the boats at anchor. A range of textures was created by the rocks, the wet sand, the glistening sea, and the brooding mountain. Wet-in-wet and dry-on-dry were the techniques I used.

William G. Muller

East River Traffic, 1900
12" x 16" (30 cm x 41 cm)

Oil on linen canvas

A steam tugboat skims along the Brooklyn, New York, waterfront while another tug assists a schooner to a Manhattan pier. This takes place on a March afternoon in 1900.

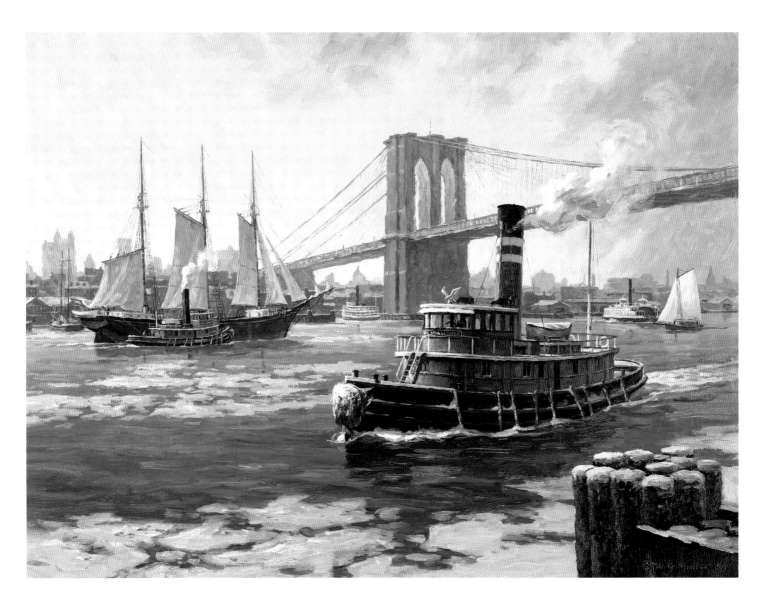

Elaine Wentworth

Heading In
20" x 30" (51 cm x 76 cm)
Watercolor on smooth surface illustration board

I have painted for many years along the mid-coast of Maine. My sea paintings depict a fascination with the rhythms of tide and surf. The leading force of energy in this piece is the elusive power of the sea, although the rocks seem to dominate the composition. An overcast day, rapidly becoming stormy, is portrayed using varied and subtle color harmonies. The smooth paper allows for easy lifting of color. Ledges, wet by the breaking waves, are painted with blurred edges to enhance the impact of the sea. Rock textures are achieved by pressing and scuffing into moist pigment. Ocean tones include soft greens, blues, and yellow ochre. The lobster boat rides low in the choppy seas and becomes part of the total environment that I was inspired to capture in watercolor.

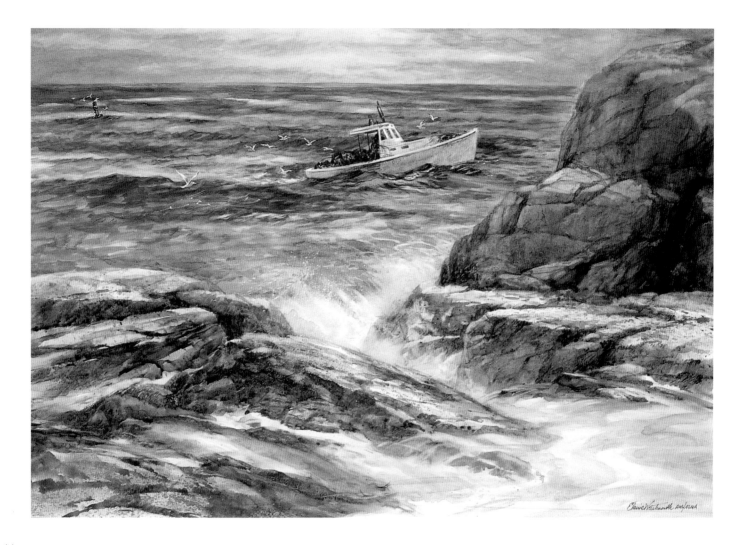

Amanda J. Hyatt

Dartmouth, U.K.

28" x 35" (71 cm x 89 cm)
Watercolor on Arches 300 g. cold press medium

There are so many boats at Dartmouth that the whole area is paintable. I chose this view to include the misty hills in the background which gives an impression of distance. The boats and man at left are the focal point. The painting was begun with a warm wash of ultramarine blue and burnt umber over the entire surface. I allowed it to dry completely and then reapplied the color for the closer hills. The color palette was kept to a minimum. It included cerulean blue and burnt sienna as the only other colors. The gray of the English environment was kept subdued to give serenity to the scene.

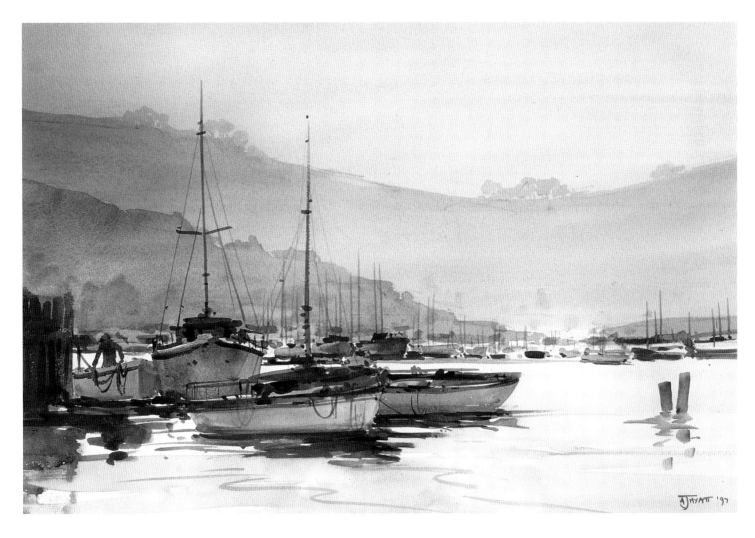

Eric Bell

Surging Sea

9.5" x 11.5" (24 cm x 29 cm)
Pastel on Sabretooth paper

I grew up by the sea and have always been drawn to it. I am awed by its magnificence and power. *Surging Sea* was painted in the Ogunquit, Maine area, a region to which I am constantly attracted for inspiration and challenge.

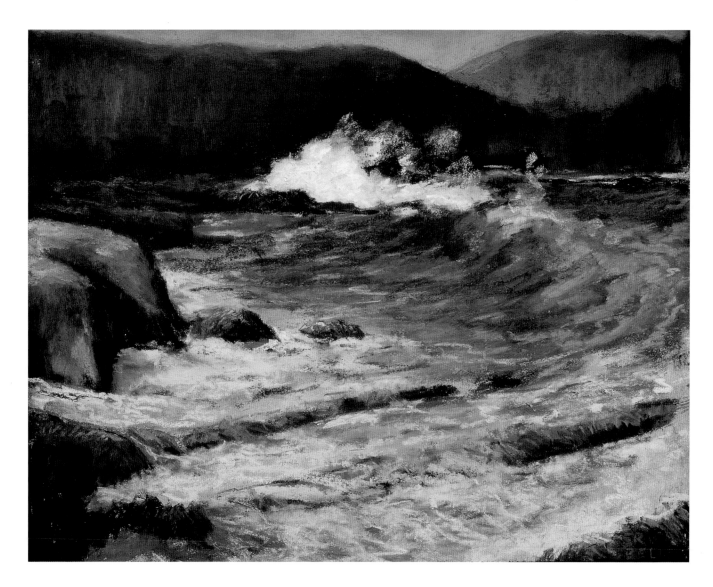

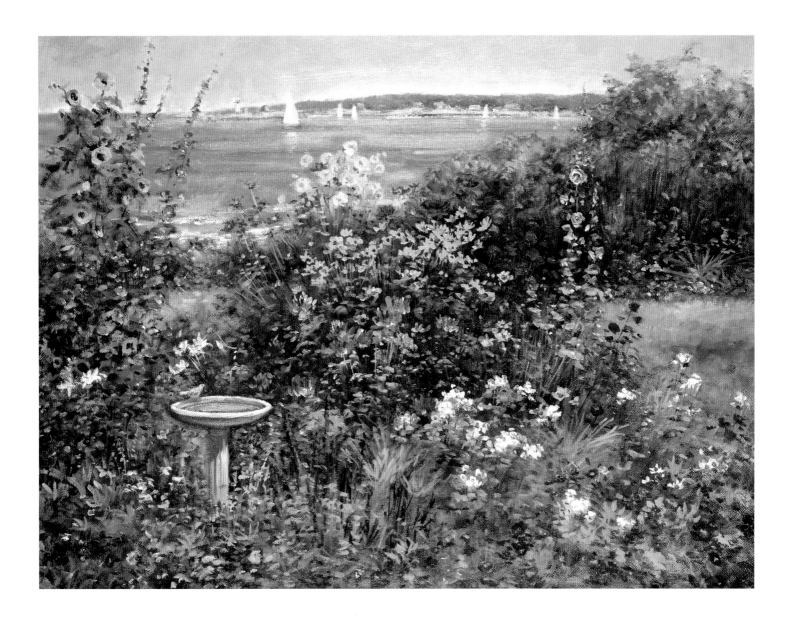

Dorothy J. Ramsey

All Nature Sings
24" x 30" (61 cm x 76 cm)
Oil on linen canvas

Some of my most memorable outdoor painting experiences were spent in this garden location at the Yankee Clipper Inn in Rockport, Massachusetts. Painting flowers by the sea is a spiritual event for me. The title of the painting is from the third line of the hymn "This Is My Father's World."

Judi Wagner

Boat at the Mooring
22" x 30" (56 cm x 76 cm)
Transparent watercolor on Arches 140 lb. cold press paper

The sunlight spilled over the rocks at Deadman's Cove, on Monhegan Island, Maine, creating a lovely view of a wooden boat at the moorings. This was a very tantilizing scene on this island, which has been an artists' haven for many years and is one of my favorite places to paint. Monhegan Island is truly blessed with natural beauty.

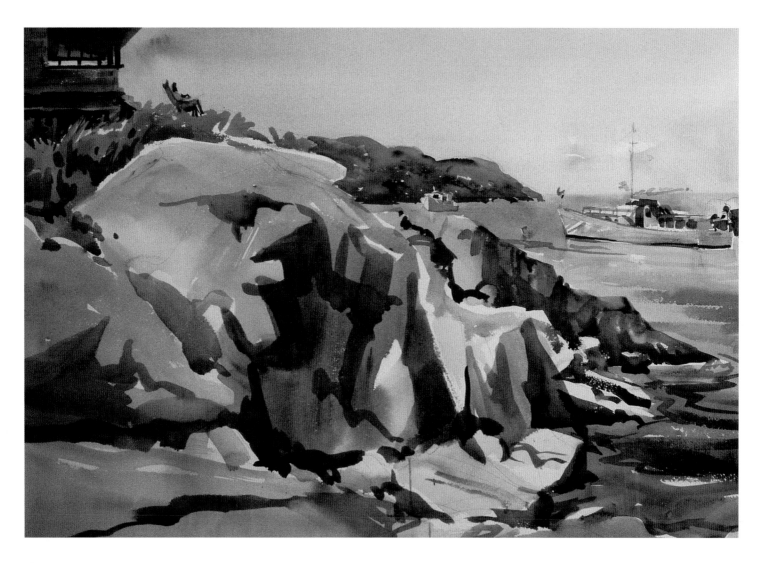

Tony van Hasselt

Round Pond Dock

15" x 22" (38 cm x 56 cm)
Watercolor on Arches 140 lb. cold press paper

It is easy to get very dark and heavy with a subject such as this. After doing a deliberate drawing of the main ingredients of the subject, I chose to "quilt" the painting together. Instead of placing large washes over major areas of the painting and then glazing smaller, darker ones over those, I started painting small pieces of color next to each other. This is much like a quilter placing different pieces of material together. The whites are painted around. On location, there simply is not time enough to bother with a masking agent. In the initial painting, the square box in the center of the painting was simply painted grey. I felt it needed something added so the word "Ice" appeared. Back in the studio, I had second thoughts and substituted the word, "Fresh," and added a lobster.

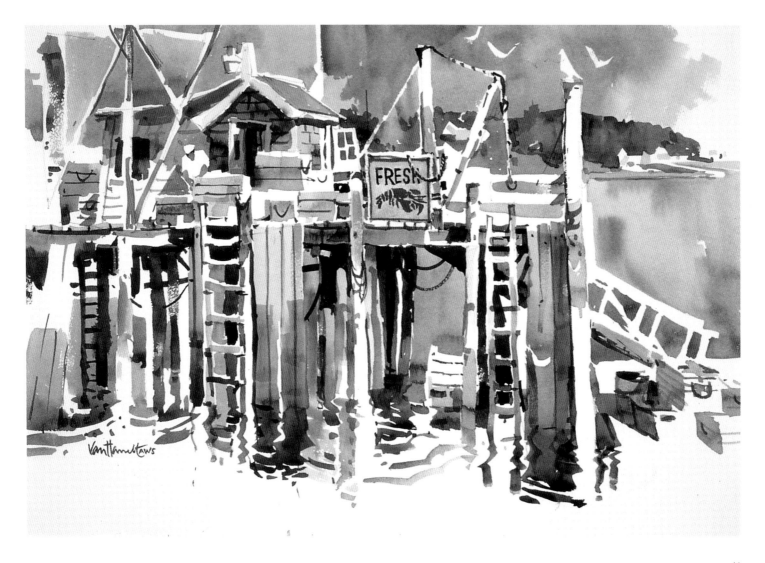

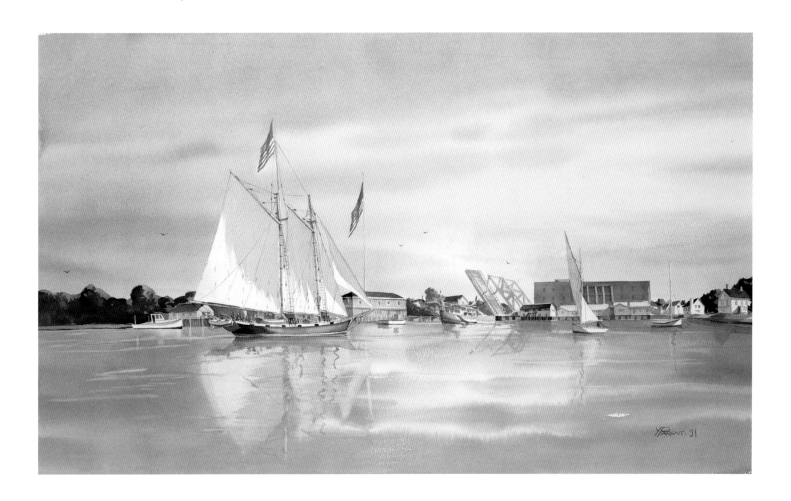

Yves Parent

Mystic and Mystic Clipper
17.75" x 32.5" (45 cm x 83 cm)
Watercolor on Arches 300 lb. cold press paper

Parent likes to combine a well-known ship or yacht with a beautiful shoreline scene. The *Mystic Clipper* was once a familiar sight on the Mystic River. She is a schooner built for day charter and now operates out of Boston Harbor. The artist, born in Normandy in 1941, was exposed to art and the sea from an early age. Sailing and painting have always been his passion. He painted Cape Horn on location and has been a crew member in many offshore sailing races. A single-handed transatlantic race took Yves from France to the Caribbean in 1982.

Sandra Saitto

Christmas in July
22" x 30" (56 cm x 76 cm)
Watercolor on 140 lb. cold press paper

I interpret the world as a kaleidoscope of light, color, and shapes. When my eye catches a combination of these elements, it is a source of inspiration. In this picture, I attempt to capture my impressions in a dramatic way.

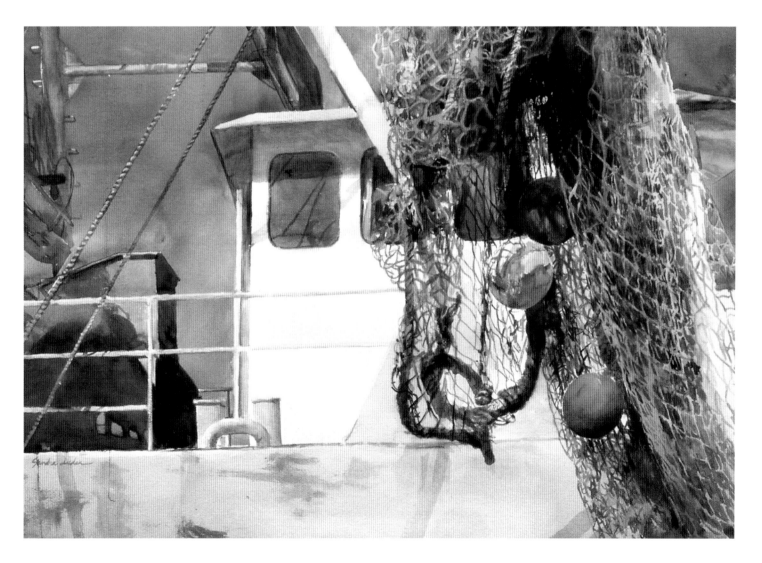

Sylvia Waters

Misty Tow
18" x 24" (46 cm x 61 cm)
Oil on Masonite

My subject for this painting is a classic wooden hull tug, the *R. E. Alexander*. Marine painting (this one in particular) calls for an exciting use of glazing techniques. The brilliant reflection on the water is the result of a wash of color in an oil base. The same approach was applied to the shadows on the *Alexander* to give her a realistic appearance. Researching these old tugs is a stimulating and rewarding adventure. This tugboat was built on Terminal Island, California, in 1925, and served the Los Angeles Harbor area her entire life.

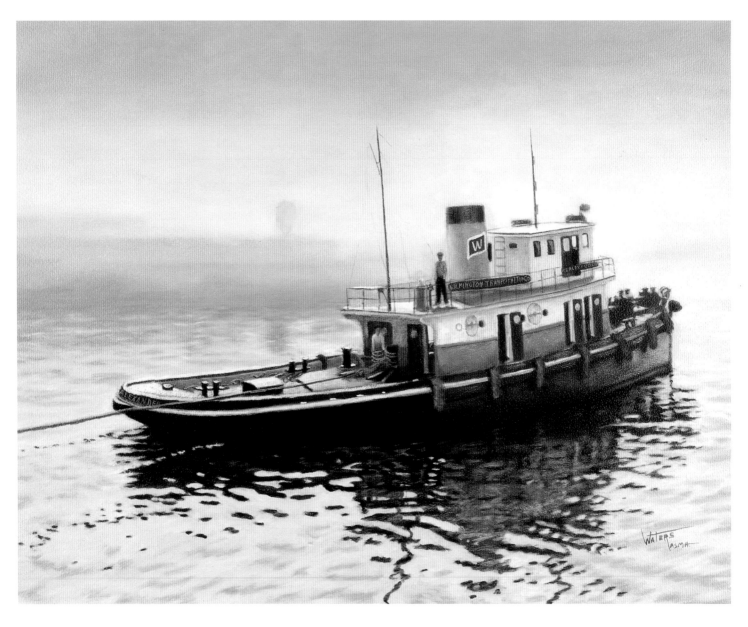

Helmut Gerth

Blowing Cove
18" x 20" (46 cm x 51 cm)
Watercolor on Arches 300 lb. rough paper

For the last twenty-six years, the rocky shoreline of the Kennebunks in Maine has attracted me and my painting classes. On the day of this painting, the area truly lived up to its name, "Blowing Cove." It requires courage. The boats, ships, and harbors make this area a difficult scene to paint.

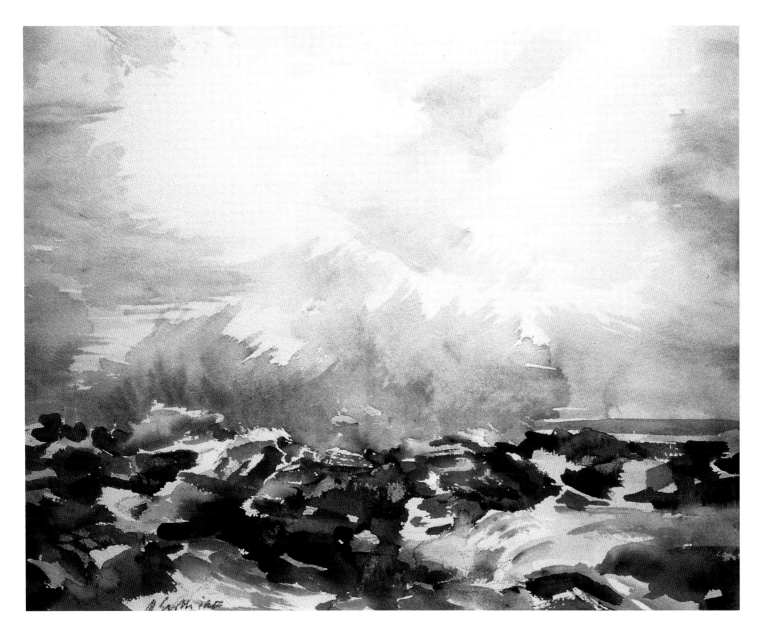

Armando B. Vilches

Up for Repairs
14.5" x 22" (37 cm x 56 cm)
Watercolor on Winsor & Newton 140 lb. cold press paper

This fishing boat caught my attention during an afternoon stroll in Tarpon Springs, Florida. I took several slide pictures and later selected one to be used in a hand-held viewer when starting my composition. A very light and loose pencil drawing eliminated the boat's cluttered surroundings. The final calligraphic touches were done with a ruling pen filled with watercolor. Sometimes, I used it sideways to obtain thicker lines.

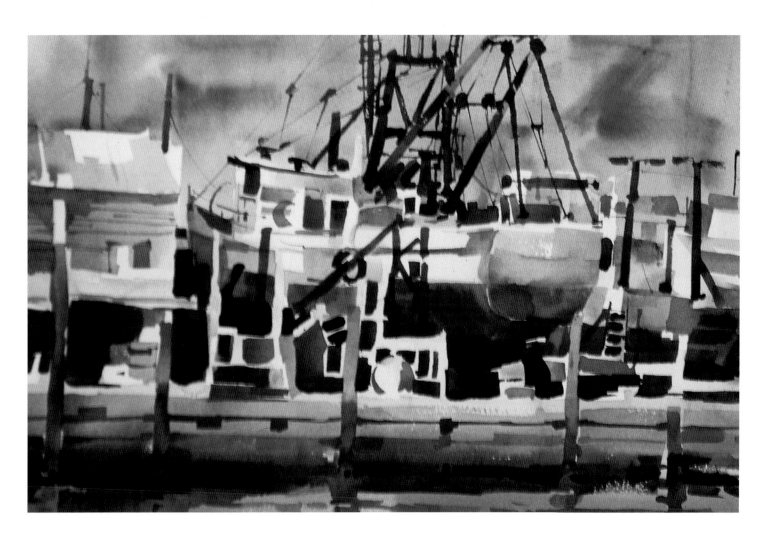

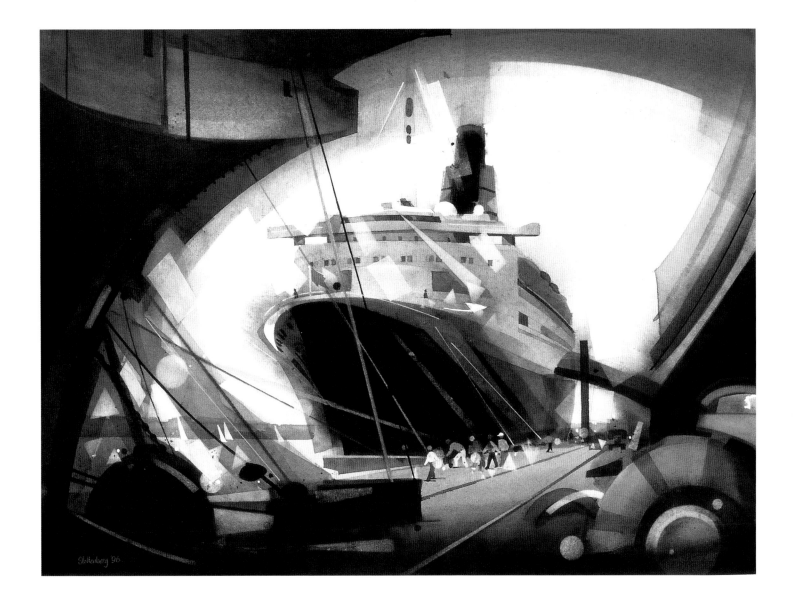

Donald Stoltenberg

Aircraft Carrier and QE2 in Boston

21" x 29" (53 cm x 74 cm)
Transparent watercolor and Chinese white on Arches 140 lb. cold press paper

The aircraft carrier bow with its docking lines at left in the foregound helped create a frame for a famous Cunard ship tied up at the Black Falcon Cruise Terminal in Boston, Massachusetts. Watercolor was initially applied wet-in-wet. Afterwards, light areas were scrubbed out through masks and stencils. Sharper forms were painted in and highlights of Chinese white were added for an accent.

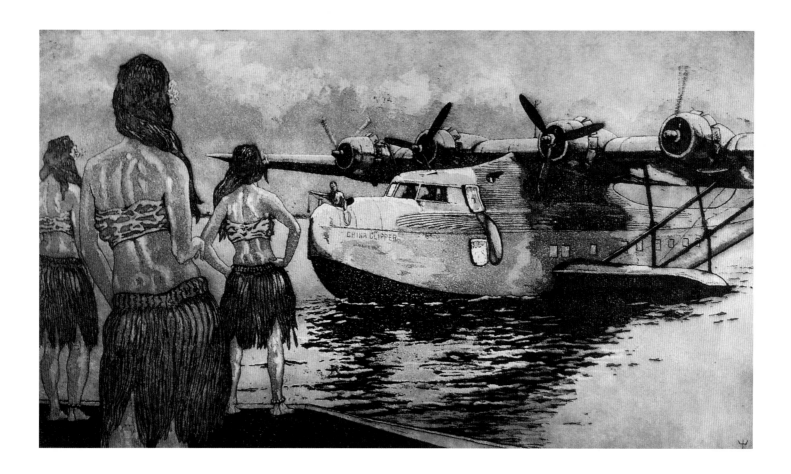

Bill Ellsworth

1935: Air Mail comes to Hawaii
8" x 14" (20 cm x 36 cm)
Etching/aquatint on Arches 140 lb. buff paper

The first airmail to Hawaii was delivered personally by Postmaster General James Aloysius Farley from Alameda, California, in November, 1935, on board the *China Clipper*. The airplane in this painting, a Martin M-130, was the second *China Clipper*, appropriately named after its predecessor.

Donald Demers

Trawling in Shoal Waters
18" x 28" (46 cm x 71 cm)
Oil on canvas

While painting this scene, I was inspired by the great traditions
of New England fishermen and the history of marine paintings
portraying adventure from the first half of the twentieth century.
This painting pays tribute to the people shown. The lives of dory
fishermen were rife with peril due, in part, to the unpredictable
weather conditions in which they toiled.

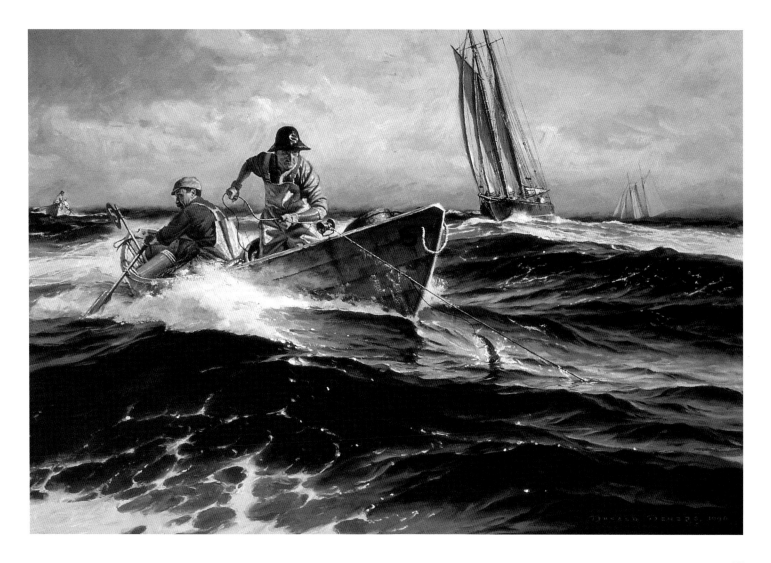

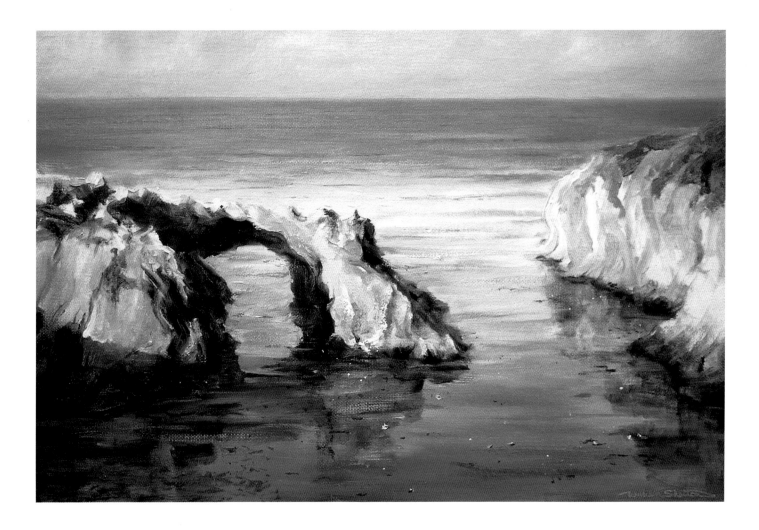

William Shelton

Some Days Are Diamonds
12" x 16" (30 cm x 41 cm)
Oil on canvas

~~~~~~~~~~~~~~~~~~~~~~~~~~~~~~~

Located on the northern California coast, the Mendocino Headlands has inspired me through the years and continues to do so. Time and again, I make the long trek to paint in this scenic area. The colors of the sea, as it relentlessly ebbs and floods, carving caves and stacks, gets my creative juices flowing, as does the California light. Once again I am struck! Morning light promising a beautiful day, warms and dissolves the shadowed crevices of millenia.

## Irene Jarrow Jaworowski

### *Reflections*
16" x 20" (41 cm x 51 cm)
Oil on canvas board

~~~~~~~~~~~~~~~~~~~~~~~~~~~~~~~

I am trying to capture the movement and beauty of the sea and the clouds in the sky so others can see them as I do. I like using a palette knife to paint.

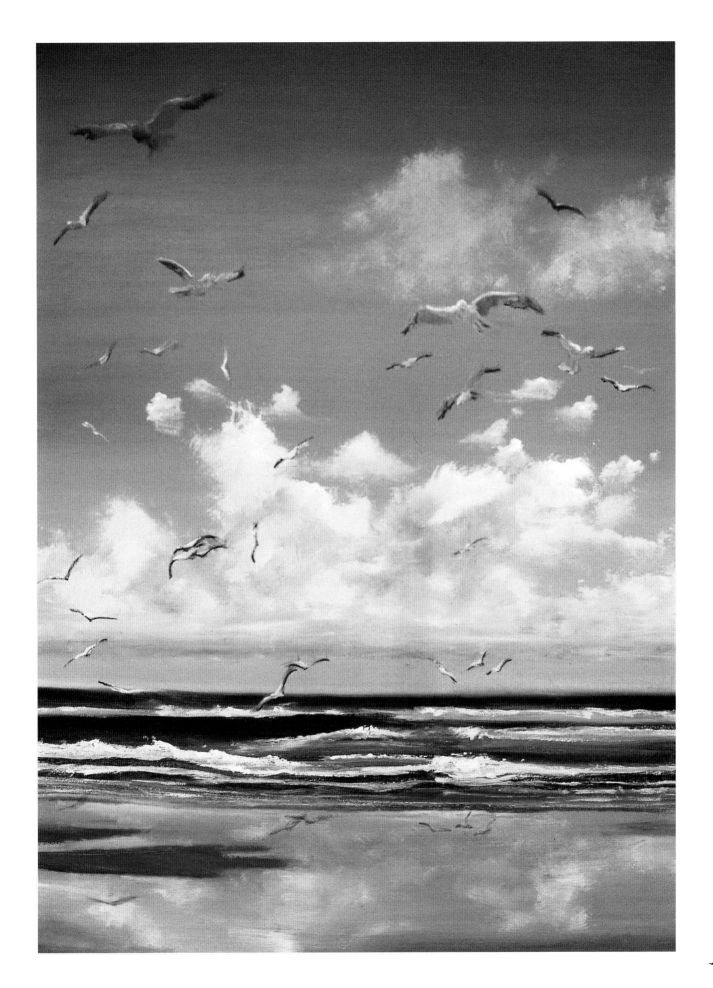

Robert Hartigan

Sindia

17" x 27" (43 cm x 69 cm)
Watercolor on 140 lb. paper

Sindia was the last of a breed of working square-riggers. She was wrecked off the Jersey shore on December 15, 1901. A straightforward watercolor seemed appropriate to capture the mood, the sails, and the rigging set for rough weather. This commissioned work was an enjoyable experience.

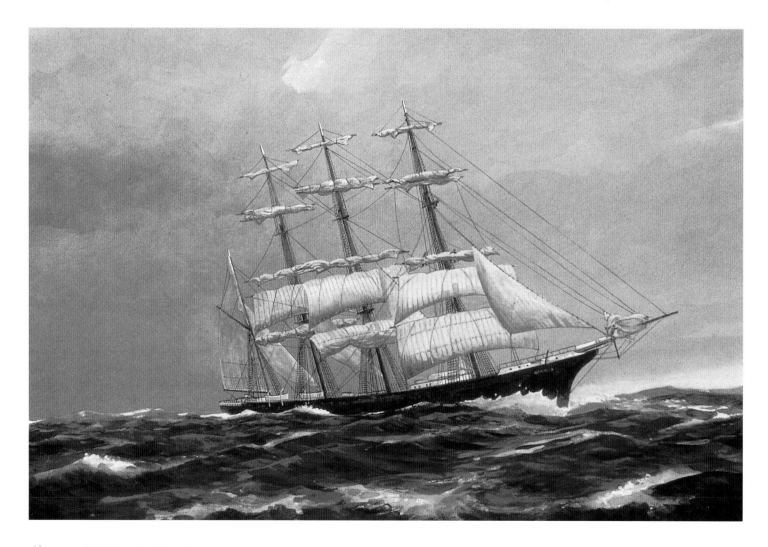

Dee Winterhalter

Raging Surf II
22" x 28" (56 cm x 71 cm)
Watercolor on 140 lb. cold press paper

Having lived near water most of my life, I find that the excitement of exploding surf on rocks tests my creative spirit. It forces me to capture the scene in watercolor. It is a challenge that can be frustrating but also satisfying.

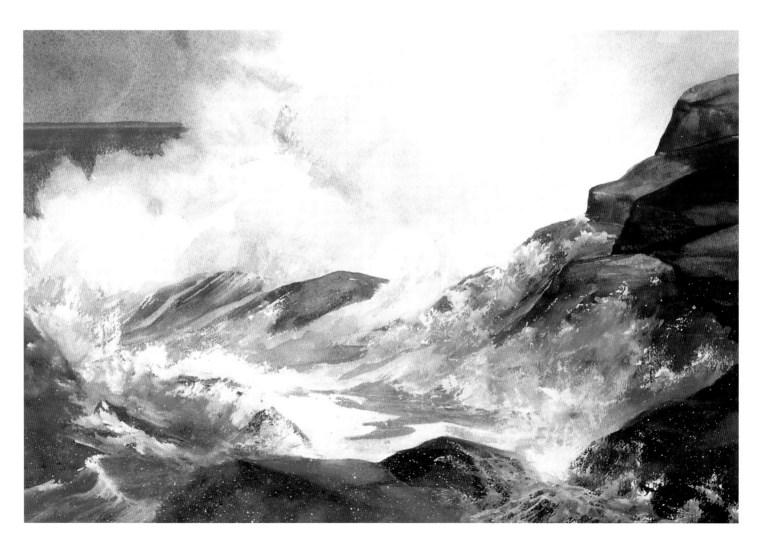

Wilma Parker

Caribbean Crew
44" x 64" (112 cm x 163 cm)
Oil on canvas

I was taken by the vivid colors, peace, and serenity of this scene. The drape of the furled sails against the vessels with their well-worn old hulls figures in my composition. The boy sitting on deck beside his resting parents completed the scene. As a frequent visitor to the Caribbean, I came across this scene on St. Croix in the U.S. Virgin Islands. An airbrush was added to the techniques used to paint this picture.

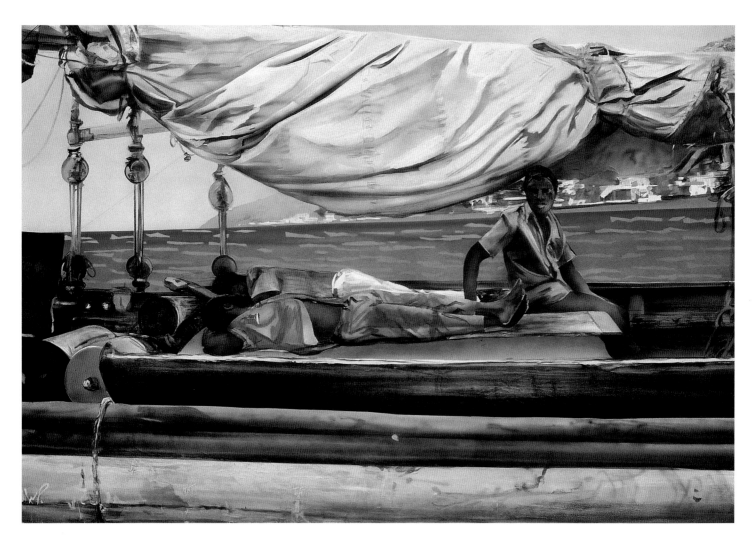

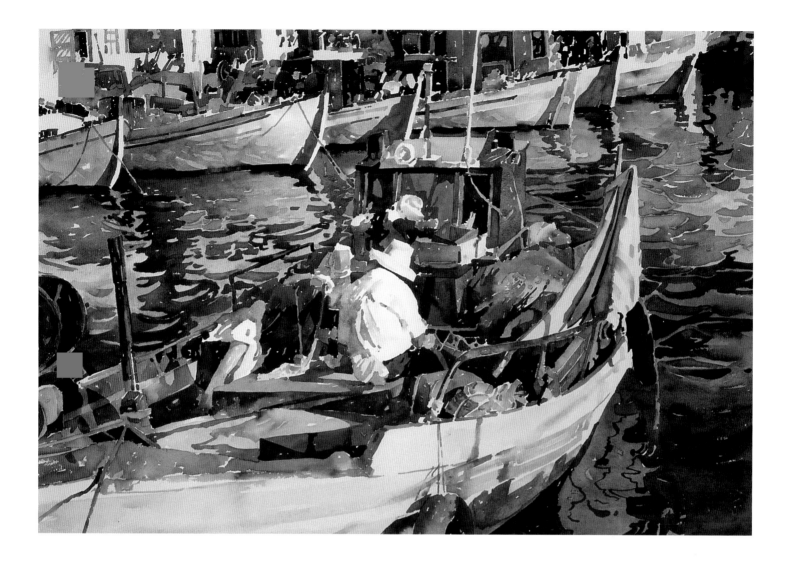

Steve Rogers

Patterns of Paros

29.5" x 41" (75 cm x 104 cm)

Watercolor on Arches 555 lb. cold press paper

Paros is the Greek island where the beautiful harbor of Naoussa is located. The vivid color of the boats and sparkling reflections on the water made a beautiful composition. My wife and I taught a workshop there in 1992.

Ward P. Mann

Smith's Cove
22" x 28" (56 cm x 71 cm)
Oil on gesso panel

This restored fishing dory complete with flags was located near my summer gallery on Rocky Neck in Gloucester, Massachusetts. It provided enough subject interest, design, light, shadow, and color to pique my interest. The result was an award-winning painting.

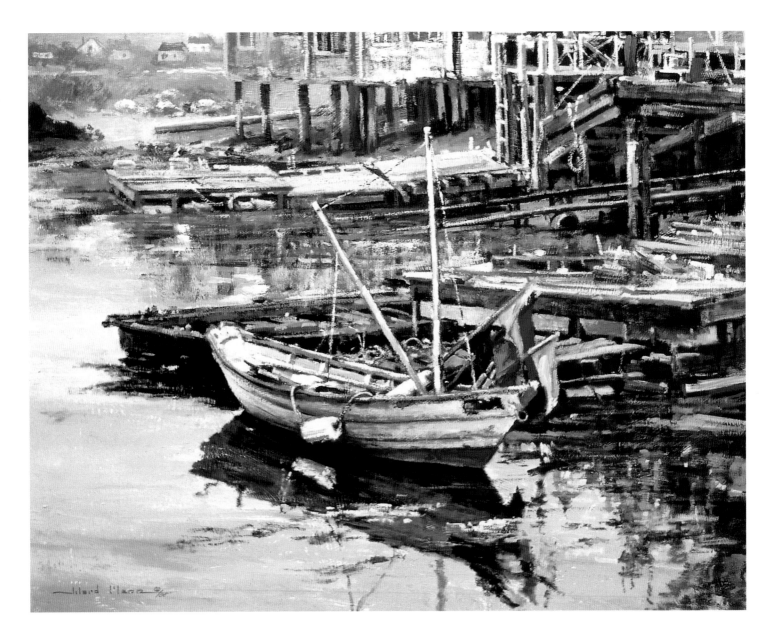

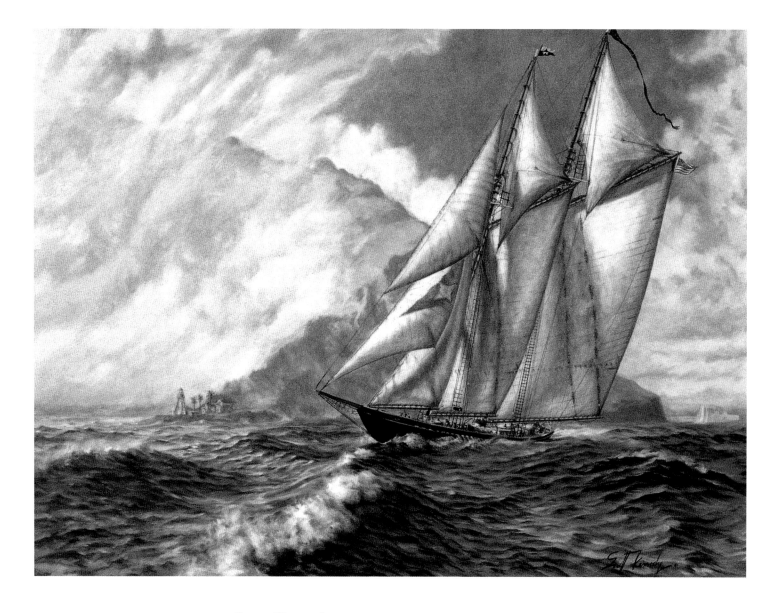

Scott Kennedy

Pilot off Point Loma

36" x 48" (91 cm x 122 cm)
Oil on canvas

Pilot, a Starling Burgess 126-foot wood schooner, was built in 1924 at Essex, Massachusetts. She had a long and distinguished career as a pilot schooner in Boston. Her wondous lines exemplify the grace of an era when working schooners were beautiful. In this scene, she is beating to windward off her home port of San Diego, California.

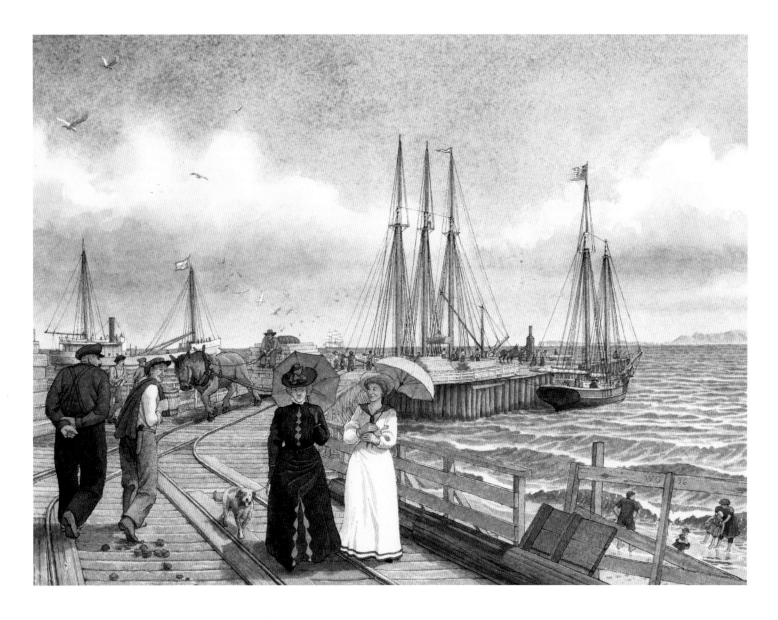

William Gilkerson

Bard's Wharf, Ventura County, California in the late 1890s

12" x 17" (30 cm x 43 cm)

Watered ink drawing with aquarelle wash on Arches 300 lb. hot press paper

William Gilkerson is an historian, author, sailor, and internationally known marine artist. This picture of Bard's Wharf in Ventura County, California, in the late 1890s is an excellent work of art showing his descriptive techniques using ink and aquarelle.

Natalie Pfanstiehl

Bowen's Wharf, Newport
10.75" x 15" (27 cm x 38 cm)
Watercolor on Waterford 140 lb. cold press paper

Bowen's Wharf is the jewel of the waterfront at Newport, Rhode Island. Brightly painted old buildings filled with tourist-oriented boutiques sparkle in the afternoon sun, casting gay reflections on the water. For a light-hearted ambience, I used mostly nonstaining transparent watercolors while painting this picture. I liked the contrast of the sleek white pleasure yacht and the workboat tied up by the Aquidneck Lobster Company in the lower left. It represented old and new Newport. Painting on the wharf, scrunched up against a piling to be out of the fishermen's way, is pure delight.

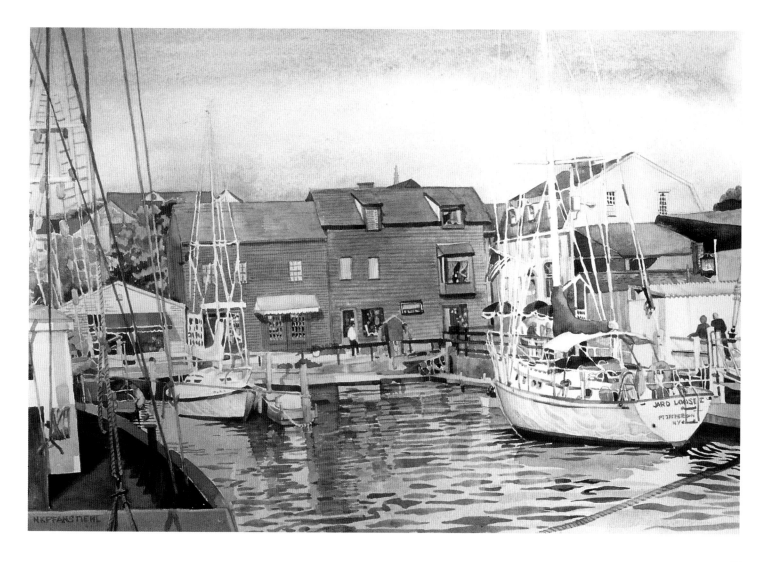

William R. Davis

Summer Sunset, Boston Harbor

30" x 50" (76 cm x 127cm)
Oil on canvas

Much of Davis's work pays homage to nineteenth-century artists such as James Bard, Martin Johnson Heade, Antonio Jacobsen, and Fitz Hugh Lane. He limits himself to about thirty colors in the palette of that period. He describes his style as "a conglomerate of a number of ideas I saw in other artists with my own refinements added." Davis is a self-taught artist whose oil paintings typically capture the serene light of sunrise or sunset on the water. This painting of Boston Harbor is a good example of his style.

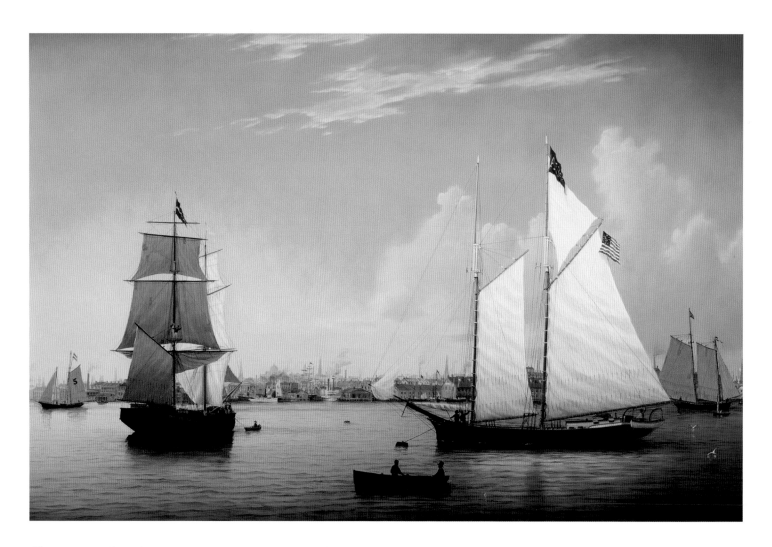

Sarabob Londeree

Billows His Will Obey
20" x 30" (51 cm x 76 cm)
Oil on canvas

The power of waves crashing on rocks inspires me to portray, on canvas, an image which depicts my emotional response to the glory of it. Three of my favorite regions to experience and paint exciting scenes such as these are Monterey, California, the rocky shores of Maine, and specifically, Monhegan Island. I sketch a very limited study in charcoal, not confining myself to anything definite at first. I start with a painting knife loaded with two or three colors and proceed with strokes that lead into the actual painting. Painting with a palette knife is very exciting and somewhat unpredictable. I work in oil, watercolor, acrylic, casein, gouache, and collage.

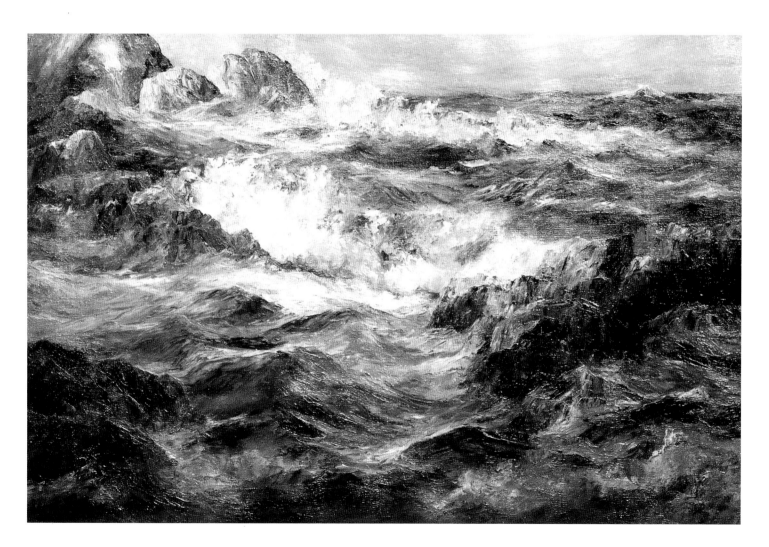

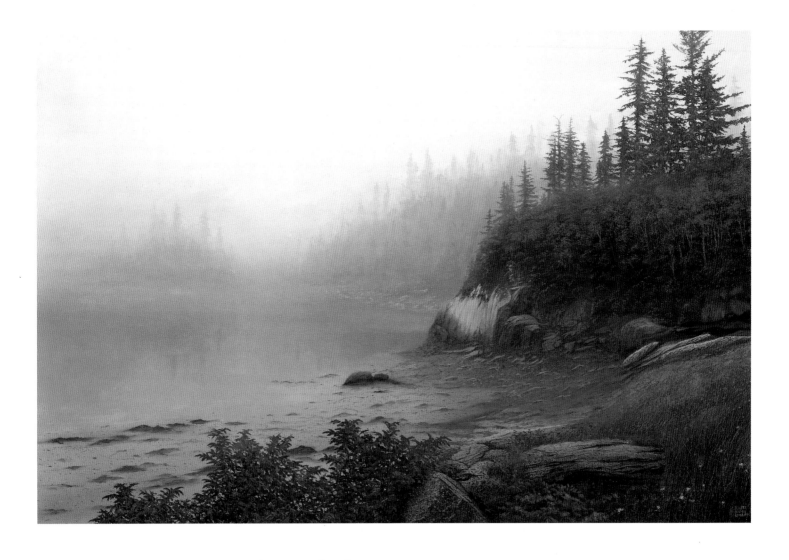

Robert T. Blazek

Fogbound
20" x 30" (51 cm x 76 cm)
Oil on linen canvas

This was painted at Mount Desert Island, Maine. Marine landscapes and coastal scenes are a specialty for me as I enjoy painting the area where the sea, sky, and land meet. Early morning is beautiful along the Maine coast. Nowhere else is the ebb and flow of nature more vivid than here. One can see it and feel it. From the rugged evergreen headlands to the bays, estuaries, and unspoiled islands, the shoreline of Maine is unmatched in its rich variety. As the morning mist drifts away, the quiet strength of the beautiful coast is unveiled.

Lilian E. Parks

Bowsprit

21.5" x 29" (55 cm x 74 cm)
Watercolor on Arches 140 lb. rough paper

Bowsprit is one of a series that was painted aboard the *Lady Frei* in Miami. I couldn't resist painting this stout and sturdy bowsprit which seemed to express the spirit of this old scarred ship. It was pointing ahead into the unknown, yet seemed so ready and willing to sail off to the next adventure. Having grown up on the cliffs by the Pacific Ocean, I love all segments of marine painting. Generally, I am a straightforward traditional watercolorist who doesn't use many gimmicks. My paintings are started with very wet washes to lay in a strong underlying basic design and rhythm. Then I build the patterns using realistic objects as the paper dries.

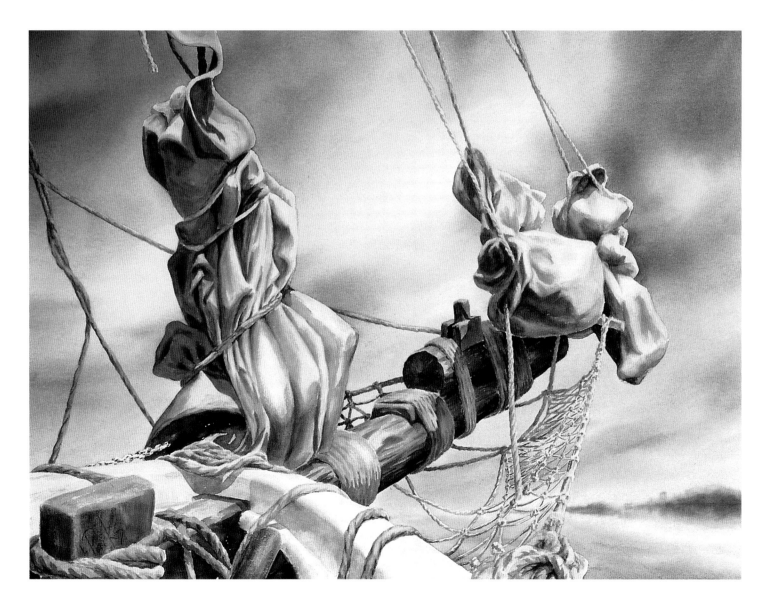

Rose Weber Brown

Red Rocks
30" x 40" (76 cm x 102 cm)
Acrylic on Crescent cold press watercolor board

Schoodic Point, Maine, was the inspiration for this painting. Because of the large size and my use of acrylics as a medium, paintings are not done on location. This painting was done in my studio using photos and my imagination. As a result, it does not pinpoint a specific locale. The rocks at Schoodic Point are rusty red, but artistic license was used to enhance their color. The technique used in the painting was mostly wet-in-wet.

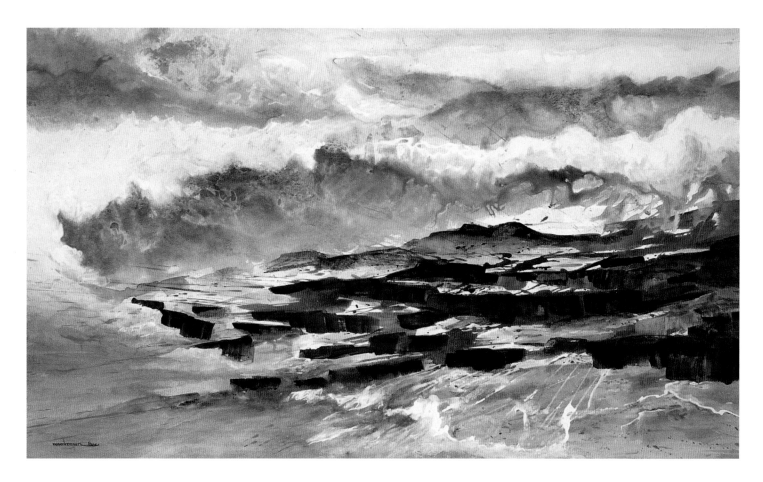

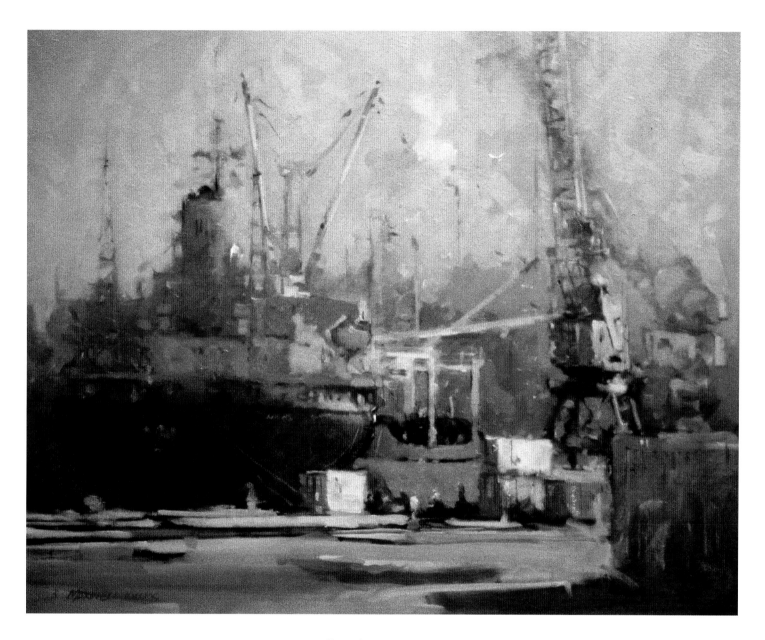

Maxwell John Wilks

Another Working Day — Port Melbourne

30" x 36" (76 cm x 91 cm)
Oil on canvas

This painting was completed in the studio from small works done on location and from drawings of the area. The scene was Port Melbourne, Australia, where there is a variety of ships and great atmosphere. My main influence in art is the exciting works by French Impressionists such as Monet, Pissaro, Manet, and Sisley, who keep the viewer completely absorbed in the mood of each scene by capturing a fleeting moment in time. Whistler, Sargent, and Sickert also provide inspiration because of their creative skills in handling their medium and their exciting choice of subject matter.

Paul Niemiec, Jr.

Paint Job

22" x 30" (56 cm x 76 cm)
Watercolor on J. B. Green 140 lb. vintage cold press paper

Off-season for lobstermen is a busy time spent mending and readying their equipment for the following season. Here, lobster buoys are painted and hung to dry in the ocean air. They are set against a backdrop of pines and evening clouds and suggest textures of a salty environment. The storage shed is adorned with a tuna weather vane pointing to open water. The drying area resembles a launch pad for missiles. Techniques used in the painting include wet-in-wet, glazing, and drybrush, with both transparent and opaque pigments.

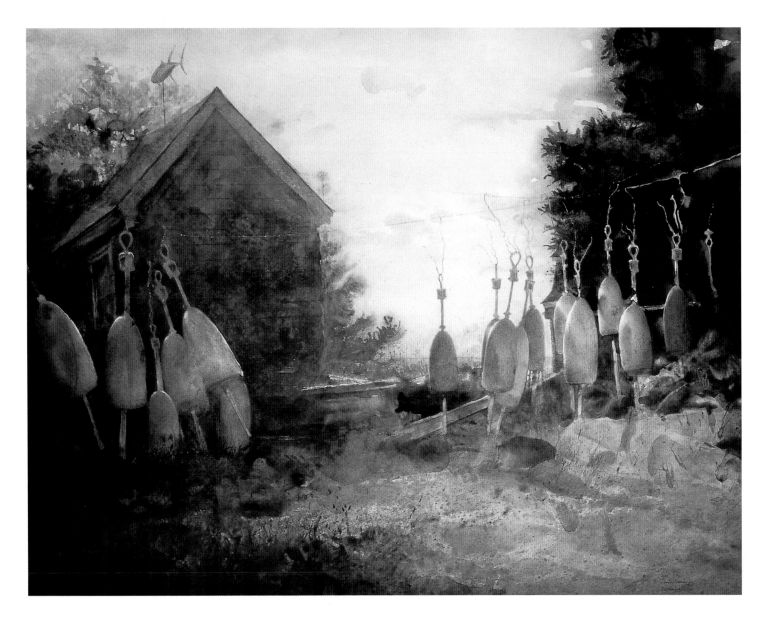

Paul Strisik

Cape Ann Skies
24" x 30" (61 cm x 76 cm)
Oil on canvas

Located in Rockport, on Massachusetts's Cape Ann, my studio overlooks the ocean and Thatcher Island's twin lights. The sky and ocean are ever changing. I observed and painted this scene after a storm passed and the late afternoon sun lit up the sky.

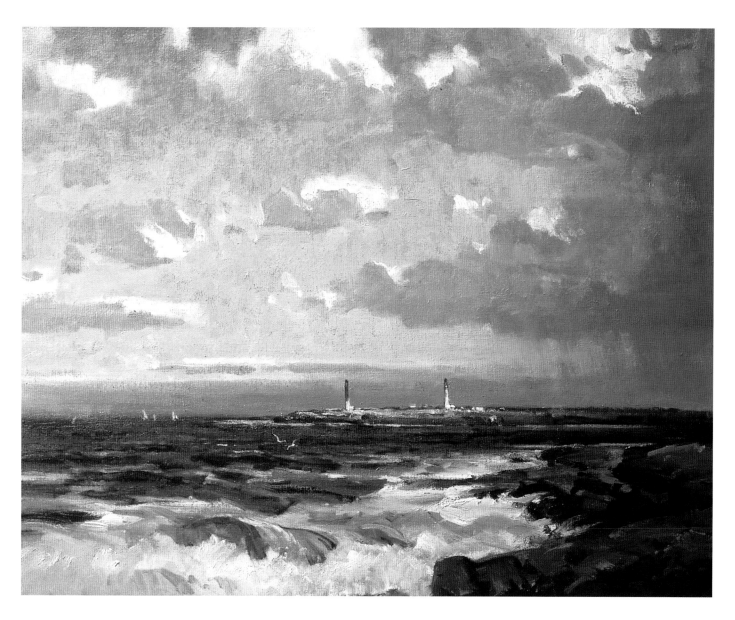

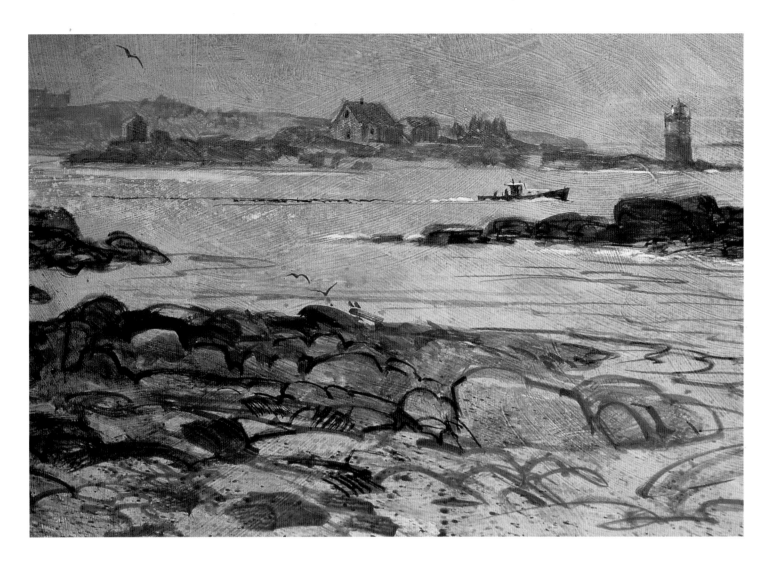

Don Getz

Gray Day
15" x 30" (38 cm x 76 cm)
Watercolor on Aquarius II paper with gesso

The Pemaquid Peninsula of mid-coast Maine has long been one of my favorite haunts. This picture was derived from a number of on-location pencil sketches and half-sheet watercolors. The Hypro paper was coated with acrylic gesso, and after it dried, I drew the subject using a rigger brush with watercolor. This allowed for easy adjustments as the watercolor can be completely washed off the gesso surface. Before drawing, I toned the entire surface with a loose wash. All white areas were washed out with a wet bristle brush or damp paper towel.

Donald O'Brien

Schooner America, 1851
18" x 24" (46 cm x 61 cm)
Oil on canvas

~~~~~~~~~~~~~~~~~~~~~~~

The schooner *America* won the historic race around the Isle of Wight on August 22, 1851. It was awarded the trophy that would eventually become known as the America's Cup. It is one of the most sought-after awards in the yachting world. The yacht was painted from several photos and from research. Its beauty is a terrific inspiration. Special techniques were used in the painting.

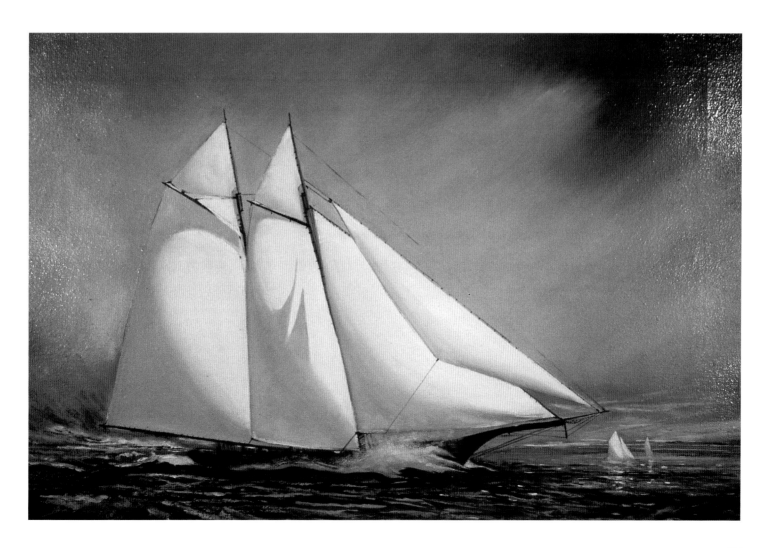

# Robert A. Wade

### *The Red Flag, Chioggia, Italy*
20" x 30" (51 cm x 76 cm)
Watercolor on Waterford 300 lb. paper

Chioggia, a working fishing port, is just south of Venice, Italy. It has been painted by many of the great artists — John Singer Sargent, Winslow Homer, and even Sir Winston Churchill. I loved the passage of light across the boats, the colorful buildings, and surroundings. This is a straightforward traditional watercolor using no masking and no tricks.

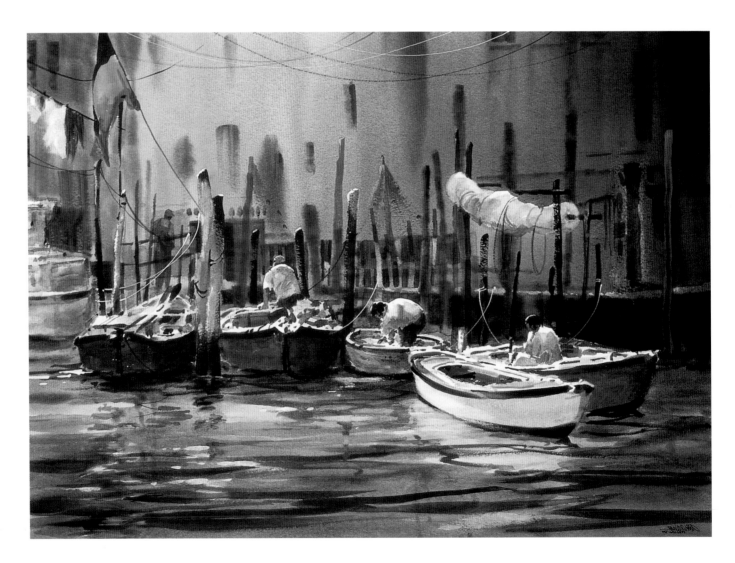

# Doug Higgins

### *Evening Sea*
30" x 40" (76 cm x 102 cm)
Oil on board

This is a work of almost pure invention. The sky was suggested from one sketch, the waves from a few others, and the rocks from somewhere else. I imagined how the light might fall across the forms and then made adjustments by scraping and restating. Sometimes I set the painting aside for a few days in order to get a fresh look at whatever it took to achieve harmony.

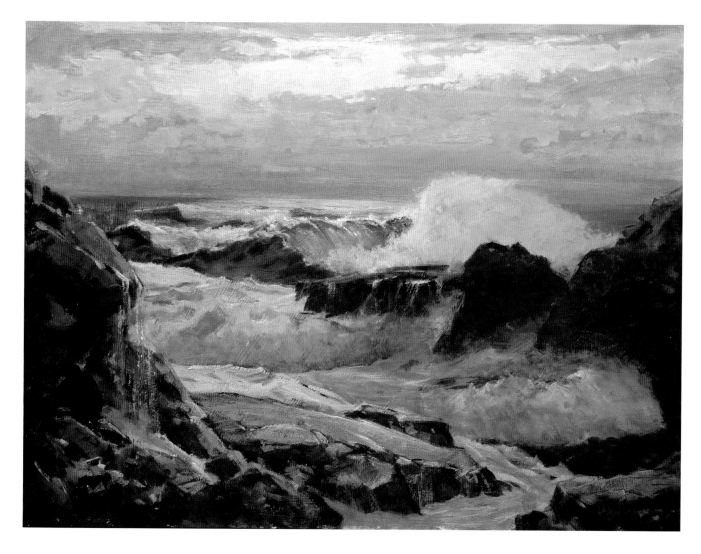

# David Bareford

### *Frostbiting at Larchmont Yacht Club*
18" x 23" (46 cm x 58 cm)
Oil on canvas

~~~~~~~~~~~~~~~~~~~~~~~~~~~~~~

This painting was commissioned by a couple who gave me great leeway in the decision-making process. The boats do not have any special design, but are called "frostbiters" after the cold weather they race in. Happily for me, their boat was yellow and stood out in a field of predominately white dinghies. I think this composition captures the excitement of the "crunch" when a close group of competitors is rounding a mark.

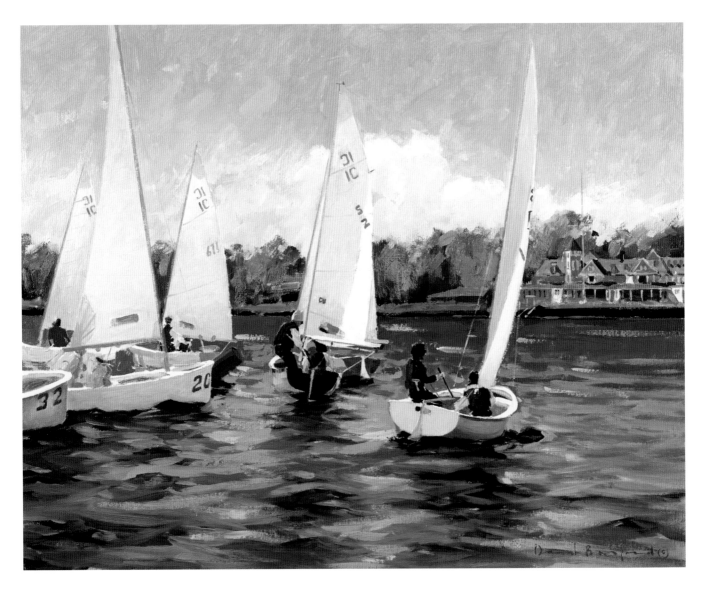

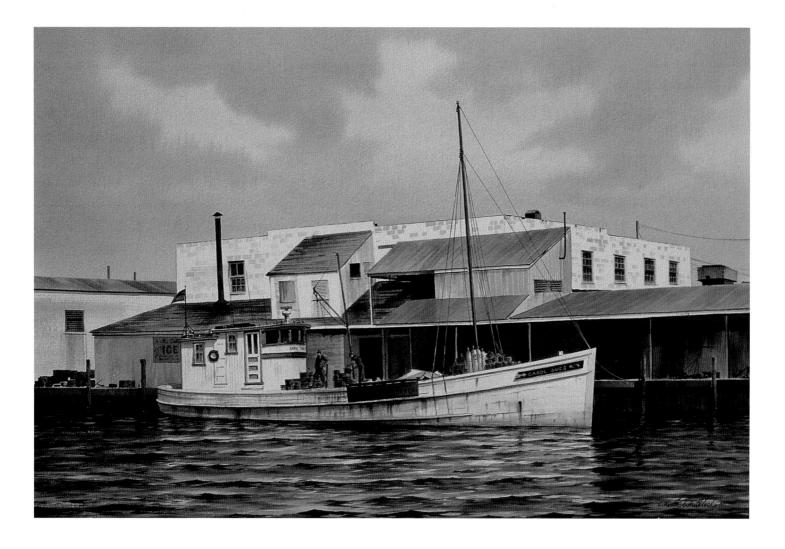

C. Keith Whitelock

Buy boat
15" x 22" (38 cm x 56 cm)
Watercolor on Arches 300 lb. cold press paper

This painting features a Chesapeake Bay buyboat loading at a dockside location in Crisfield, Maryland. This type of boat was traditionally used to buy oysters directly from the watermen on the oyster grounds. They were then transferred to the oysterhouse for packing. Some boats were specifically built for this purpose, while others were converted from older bay craft such as schooners. Today, the few that are left are hauling whatever they can according to the season. I painted this one as it appeared just a few summers ago. I especially liked the light hull outlined by the dark areas of the building behind. One of my favorite things about these old wooden boats is the way that rust streaks mark the hull. I think it adds to the character of the boat in my paintings, but the watermen often fuss at me because they prefer the newly painted look!

Jack Coggins

Longlining, Penobscot Bay
20" x 30" (51 cm x 76 cm)
Oil on canvas board

The Penobscot Bay area of Maine is a favorite place of many marine painters, including me. The small sloops are typical of the region and, depending on the season, are used for line fishing, netting, or lobstering. Regrettably, these attractive vessels are being slowly replaced by power boats.

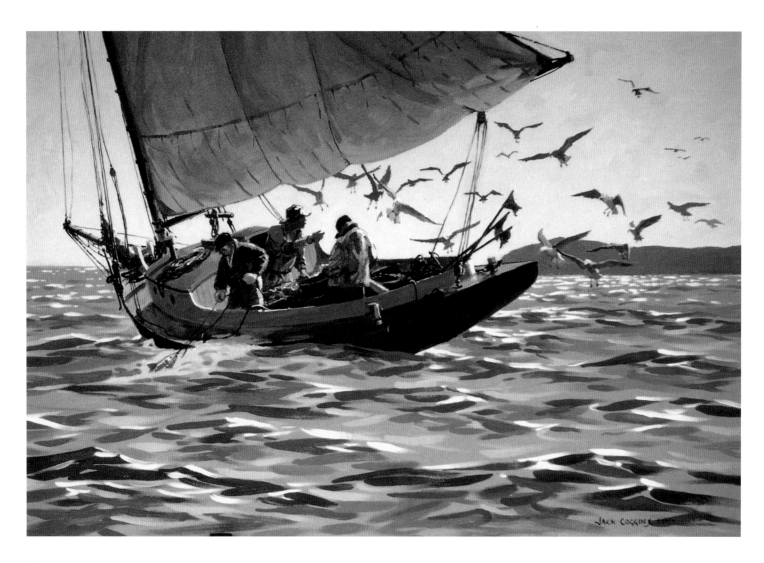

Catherine Arnera

La buvette/The Outdoor Café

21" x 32" (53 cm x 81 cm)
Oil on canvas

~~~~~~~~~~~~~~~~~~~~

This is a scene from Tannay, a town on Lake Geneva, Switzerland. With the sailboats, yellow parasols, and reflections on the water, this view immediately reminded me of both Renoir's and Monet's *La Grenouillère*. Both artists painted simultaneously at a location just south of Argenteuil in 1869. The outdoor café offered the same extreme complexity of subject framed with the enormous open space of Lake Geneva, which is broken up by jetties, moored sailboats, and fishing vessels. The scene is placed against a breathtaking backdrop of the French Alps and their foothills. The difference in values and the effect of dark foliage against the light sky, water, and mountains create a strong sense of space. It is unfortunate that modern development is causing this environment to disappear.

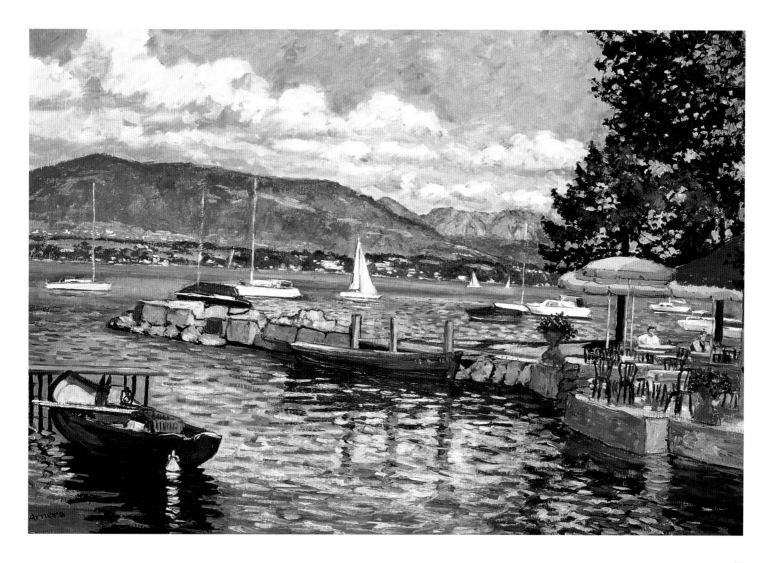

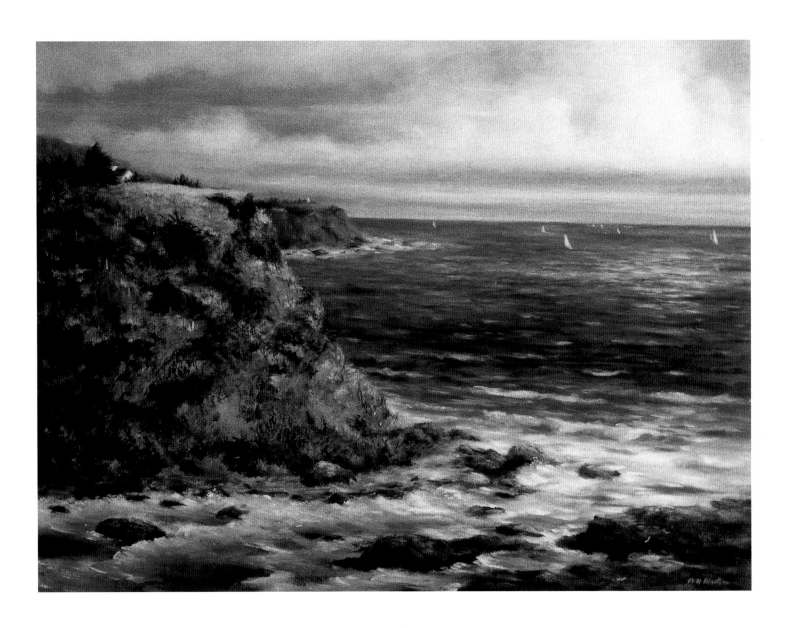

### Barbara W. Masters

**Point Vicente from the North**
18" x 24" (46 cm x 61 cm)
Oil on cloth-mounted Masonite

~~~~~~~~~~~~~~~~~~~

The seemingly tiny sailboats viewed from the heights of the cliffs in Palos Verdes, California, are a source of pleasure and inspiration for artists. The dazzling display of reflections of the billowing clouds overhead provides an interesting contrast to the relative calm of the Pacific Ocean. The cliff and beaches along the ocean are favorite places for artists to sketch and paint. This painting was done from sketches collected in that area.

Doris Sampson

Detroit River Queen

24" x 36" (61 cm x 91 cm)
Acrylic on canvas stretched and prepared by the artist

This painting exemplifies Sampson's rendering of an old freighter. It is from a classic photo in the Howard Weis collection. The scene is circa mid-1970s. The difference between this laker and most all others is that this one still sails while the others have been scrapped. Now her pilothouse and after-end have been removed and she has been converted to an integrated tug-barge. *Detroit River Queen* was a most difficult and time-consuming work which took the artist five weeks to complete.

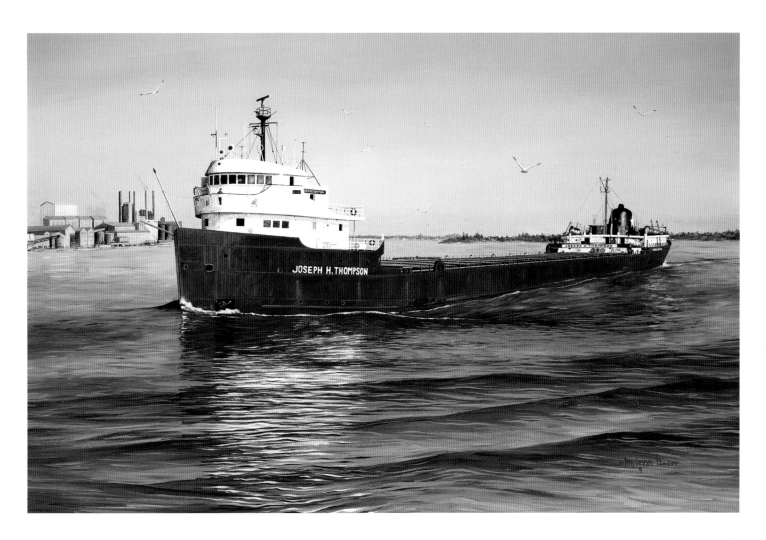

Robert Tandecki

Gold Rush
14" x 20" (36 cm x 51 cm)
Watercolor on Arches 300 lb. rough paper

This is one of the hundreds of vessels that traveled from Seattle, Washington, to Nome and Skagway, Alaska, during the Alaska gold rush. I've traveled this route via land and water and even panned for gold in Nome. Although my paintings are sometimes mistaken for photographs, it's the mood of the painting that I want the viewer to enjoy most. My favorite time to paint and study is the fall and winter months.

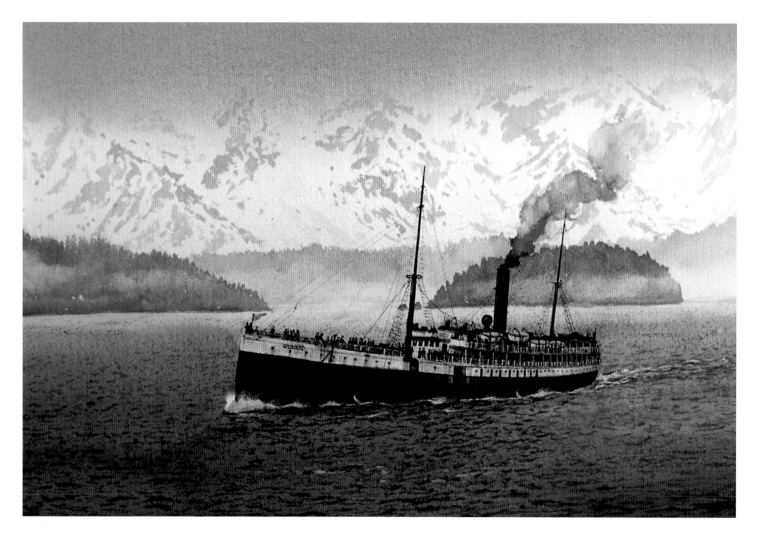

Dean F. Waite

Proud Ladies of the 50s
24" x 33" (61 cm x 84 cm)
Oil on linen canvas

I have been aboard these ships, built models of them, and painted them many times. My wife and I sailed to England on the *Queen Elizabeth* in July, 1965. My painting shows the Swedish liner, *Kungsholm*, passing a brace of the world's largest ocean liners. The first three are the *RMS Queen Elizabeth*, the *SS Liberté*, and the *SS United States*. A Boeing propeller-driven airplane, a forerunner of the modern jet fleet, is flying overhead. It signifies that the air transport era has begun and that the tradition of the grand transatlantic liners has begun to fade.

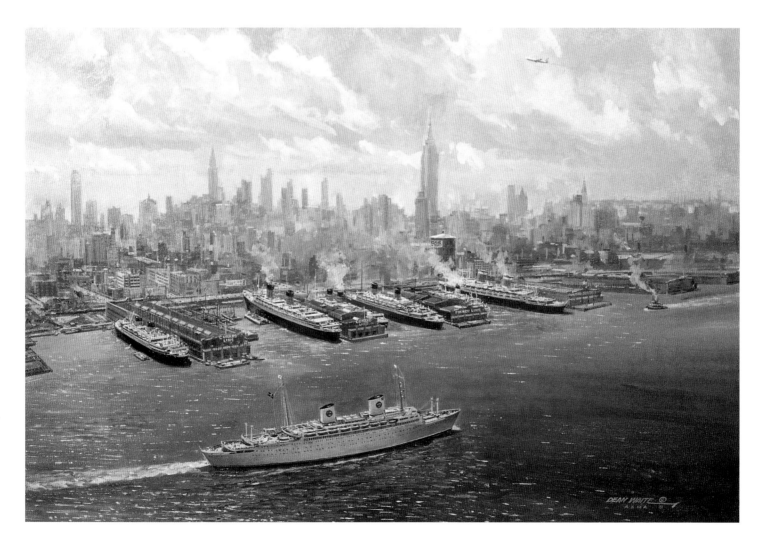

Lorraine E'drie

Sea of Mystery
22" x 30" (56 cm x 76 cm)
Watercolor on Arches 300 lb. cold press paper

The force of the sea against a rocky shore has always fascinated me. On the Oregon coast, what a mystery of strength can be witnessed as waves crash against the rocks and foam goes high in the air! Watercolor seems the best way to capture the spray and movement with a wet-in-wet technique. When the painting dried, deep-hued glazes were placed on the rocks and trees to gain depth.

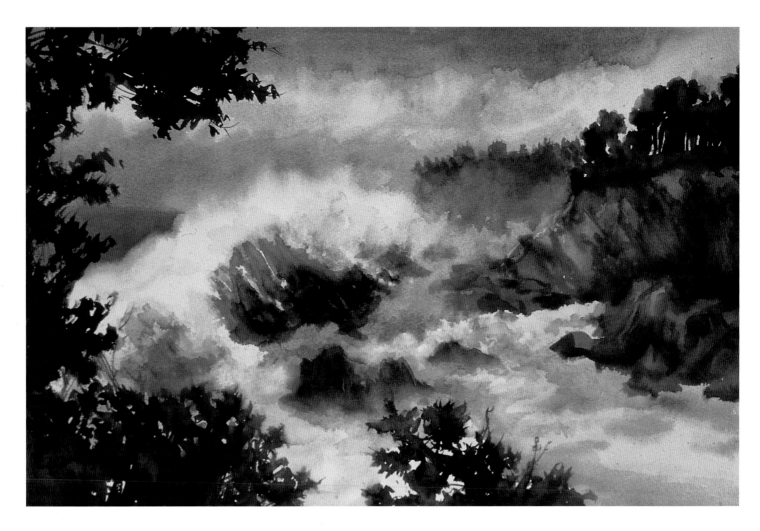

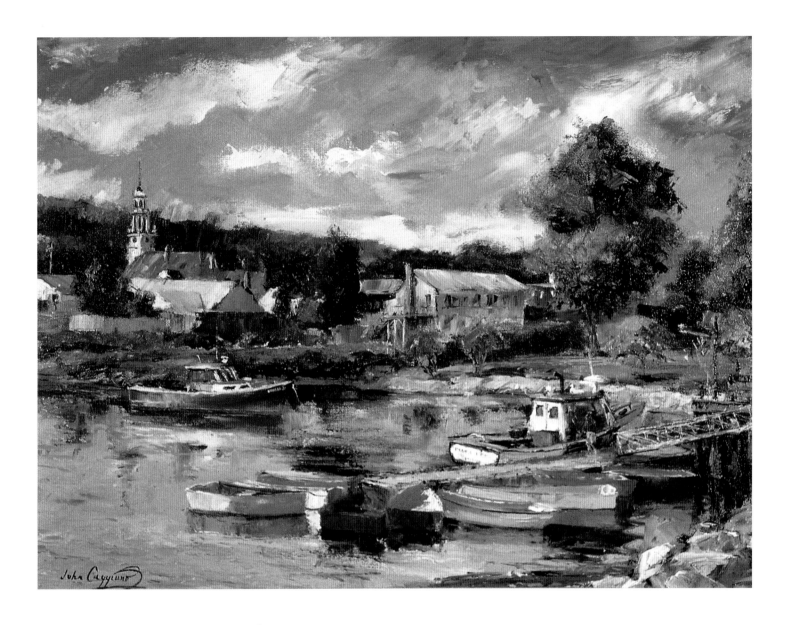

John S. Caggiano

Manchester Harbor
18" x 24" (20 cm x 61 cm)
Oil on linen canvas

This was painted on location at Manchester-by-the-Sea, Massachusetts. I was inspired by the interplay of boats, light, and design elements. It was painted with a palette knife.

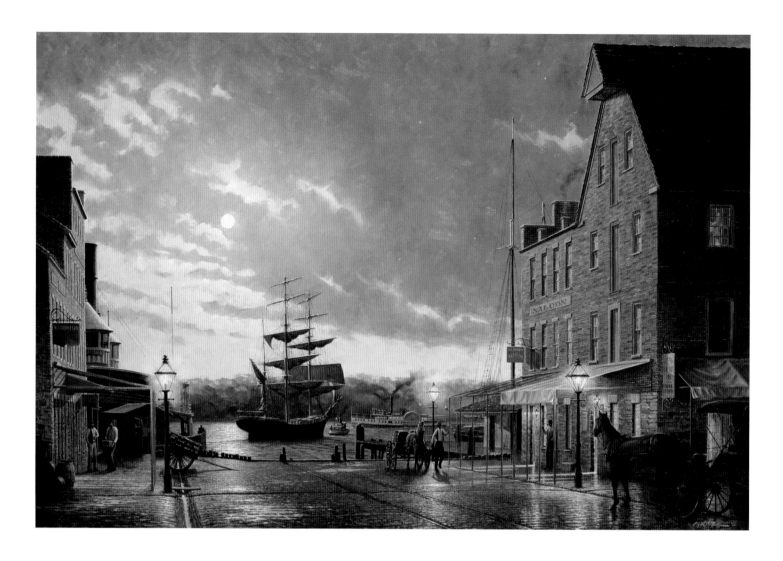

John M. Barber

Old Town Alexandria by Moonlight
23.5" x 35.5" (60 cm x 90 cm)
Oil on canvas

Alexandria, Virginia was a major trading center during the eighteenth and early nineteenth centuries. Here we see the sailing vessel, *Talisman* (built in Baltimore in 1860), being towed downstream to begin her voyage to South America for a cargo of guano, which was used as fertilizer. Cargo arrived at this port from Great Britain and other European ports, the West Indies, and numerous East Coast cities during that era. The waterfront is shown aglow with gaslight under a rising moon, which bathes the busy harbor in a romantic light.

Frank P. Saso

Pemaquid Point

22" x 38" (56 cm x 97 cm)
Watercolor on cold press illustration board

Traveling the coast of Maine is a painter's delight. With each town or cove, many scenes unfold. One of these scenes was Pemaquid Point. A dark sky silhouetted the lighthouse while the wind blew the sea against the rocks to create a moment in time. There is always enjoyment in painting the surf because of the dramatic effects of the disturbed water. I also create excitement by designing and painting movement with light and dark patterns.

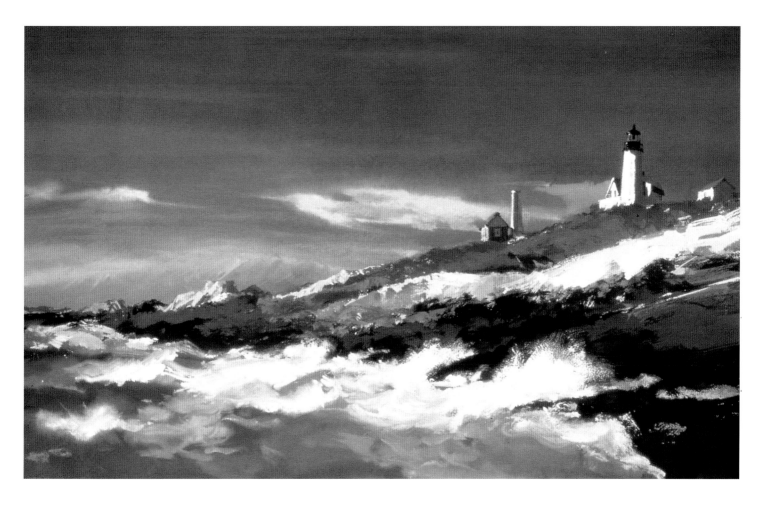

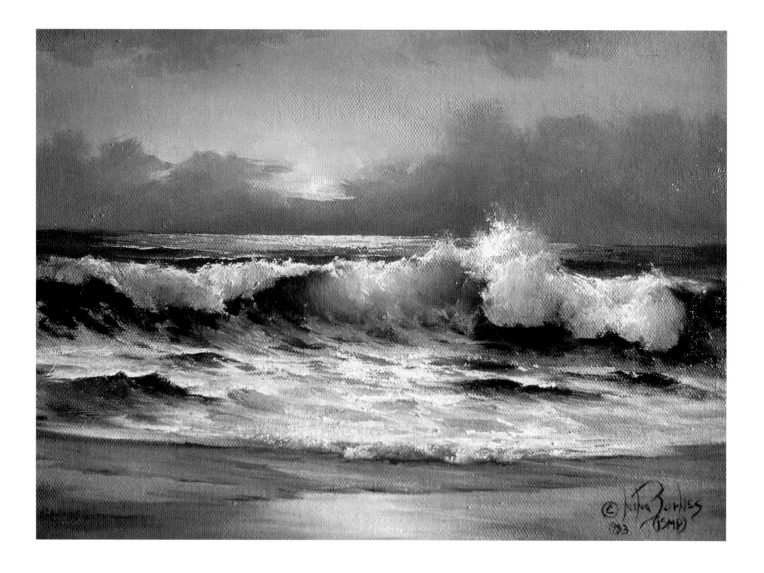

Nina Barnes

Carmel Sunset
9" x 12" (23 cm x 30 cm)
Oil on canvas

~~~~~~~~~~~~~~~~~~~

The translucent breaking wave with the color of the sky coming through inspired me to paint this scene. Distant storm clouds on the horizon behind the foaming action on the beach framed the picture.

## L. L. (Lee) George

### *Waiting*
36" x 24" (91 cm x 61 cm)
Oil on Woolsey Gold Star pre-stretched canvas

~~~~~~~~~~~~~~~~~~~

This is a late fall scene on the mud flats near Anchorage, Alaska. It pictures a fishing skiff moored between an anchor and a point above high tide. The "waiting" of the title is depicted by the sun waiting to break through the overcast sky, the skiff waiting for the tide, and the seagulls waiting to go to the fishing grounds. I use mops and blenders a lot to capture the softness of the atmosphere.

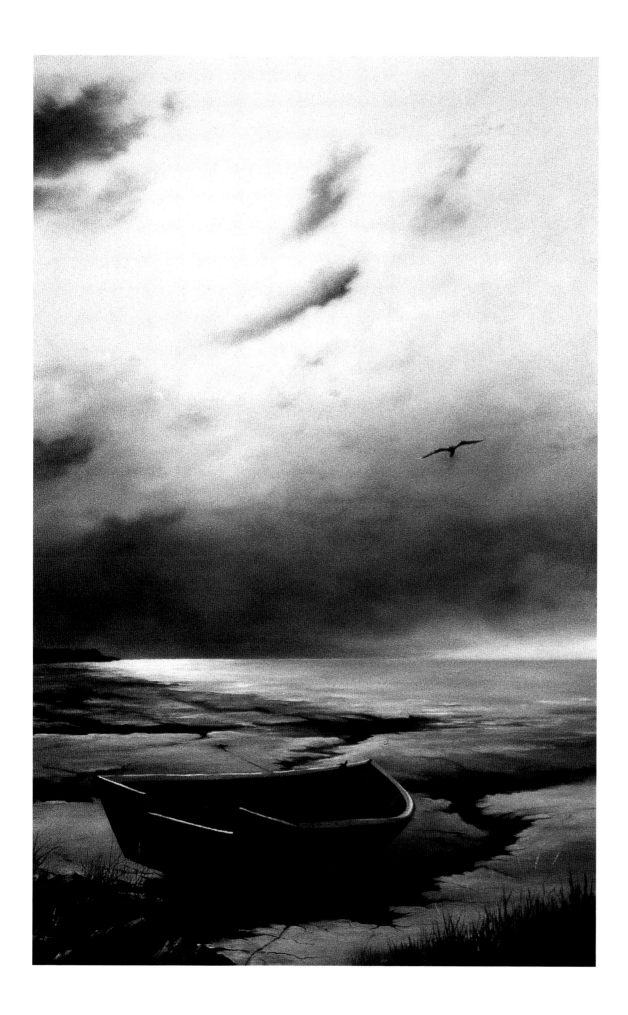

Jerry Rose

Robert Russell
18" x 24" (46 cm x 61 cm)
Oil on panel

This is a portrait of my good friend Robert Russell. I painted it in a small mangrove-lined harbor in front of his home in the northern Bahamas. My idea for this painting was to capture the feelings of a man enveloped by his environment. The dark brooding water background was a perfect foil for the figure and the boat. I chose oil for my medium because it is particularly suited for laying in the darks of the water. One of the difficulties of the painting was trying to effectively convey the two properties of water—reflections and clarity. Painting Robert's feet and the reflection of the boat was a definite challenge.

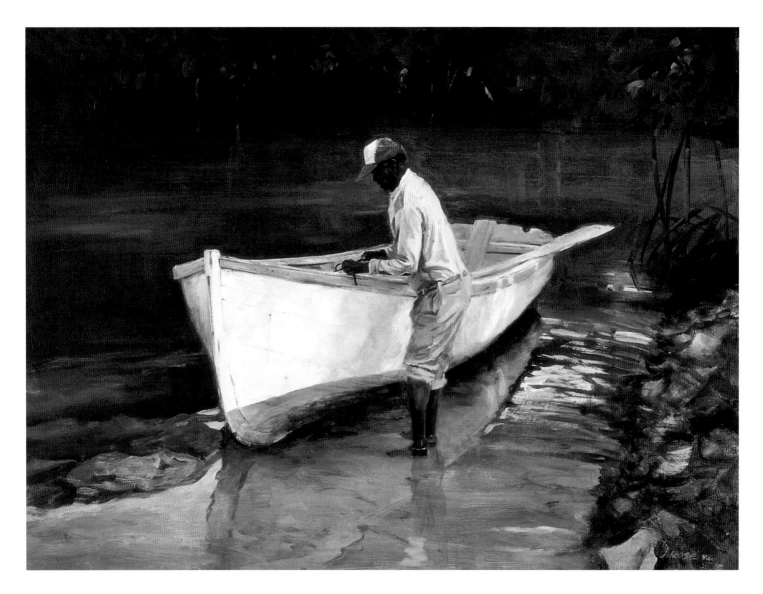

Lorraine J. Grinnell

Autumnal Tide

18" x 24" (46 cm x 61 cm)
Oil on canvas

Above all, I want my paintings to have feeling. My greatest compliment after receiving first place for *Autumnal Tide* at a Carlisle, Massachusetts, art show came from a spectator who said to me, "I can feel the mist." Feelings are what I wish to convey most.

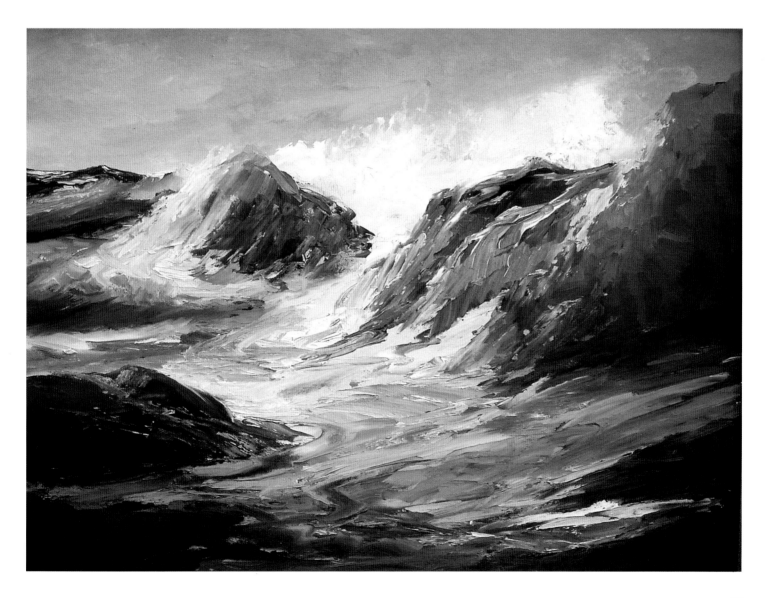

Harold Kloongian

Rocky Neck Marine Railway
24" x 30" (61 cm x 76 cm)
Oil on linen canvas

The ships in this painting were being repaired at a marina located on the tip of Rocky Neck in East Gloucester, Massachusetts. The marina consists of two railways constructed side by side with piers in between. They are the largest of their kind in the Cape Ann area. The rusted, streaked tugboat on the left railway is the boat *Saturn*. On the right railway is the sailing vessel *Corwith Cramer*, with its comparatively clean, white and red hull. The contrast of the size and conditions of both vessels was artistically appealing. Several visits to this location were necessary to gather more details of the scene.

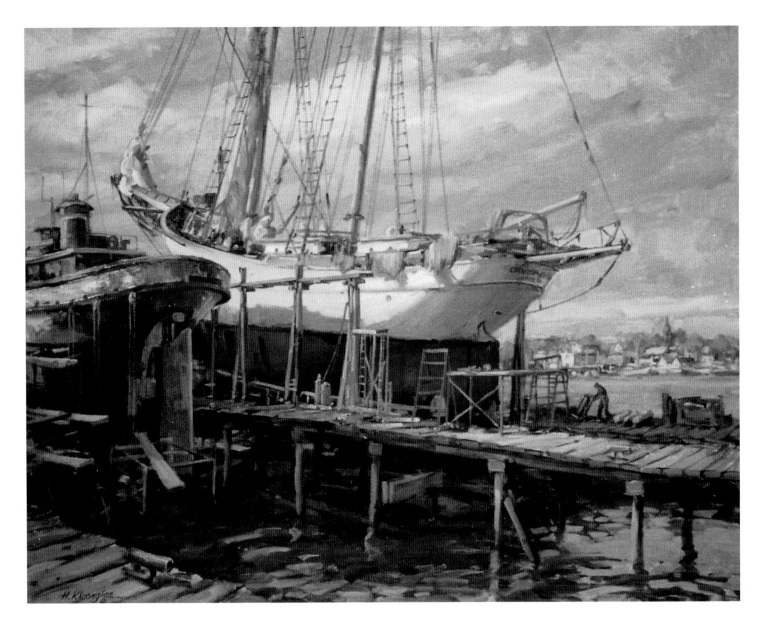

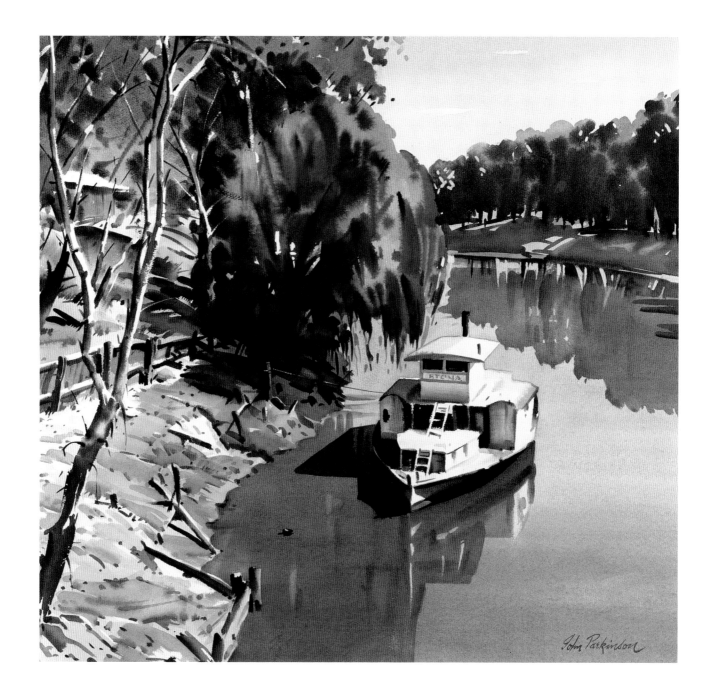

John Parkinson

Morning Light on the Murray River
21" x 28" (53 cm x 71 cm)
Transparent watercolor on Arches rough C40 G/M2 paper

The paddle steamers on the Murray River in Australia have always been a fascinating attraction for me. The *Etona* is a noted vessel once used for church services along the Murray. It was funded by the boys of Eton College in Great Britain, thus its name. Lord Montgomery, the famous British field marshall, sailed on the vessel as a schoolboy and played the church organ at river services.

Gerald J. Fritzler

The Main Canal — Chioggia

18.25" x 27.25" (46 cm x 69 cm)
Watercolor on Crescent hot press watercolor board 5115

While on a trip to Venice, Italy, I took a ferryboat ride to the fishing community of Chioggia. It had three different canals with fishing boats. The main central canal was the oldest and seemed to have more of the local traffic and private boats. This view caught my attention as I looked out from my vantage point on a bridge to see a fisherman coming down the canal in a motorboat. I most enjoy painting areas where boats are docked or being repaired in dry dock.

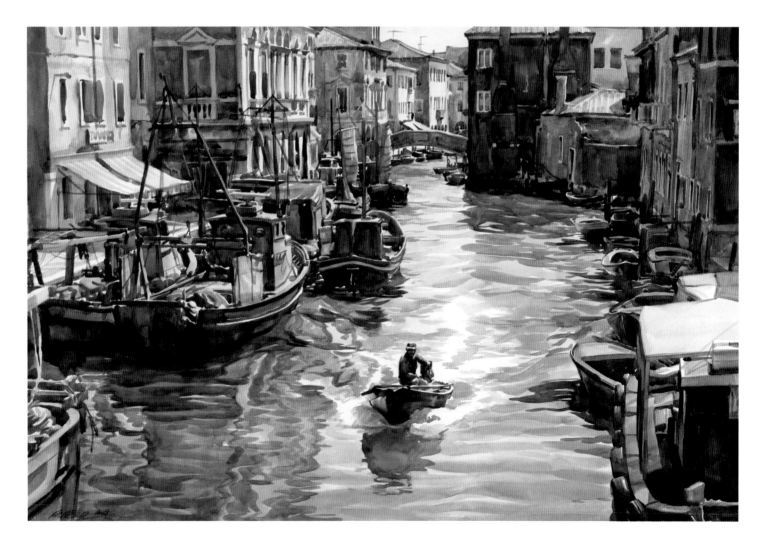

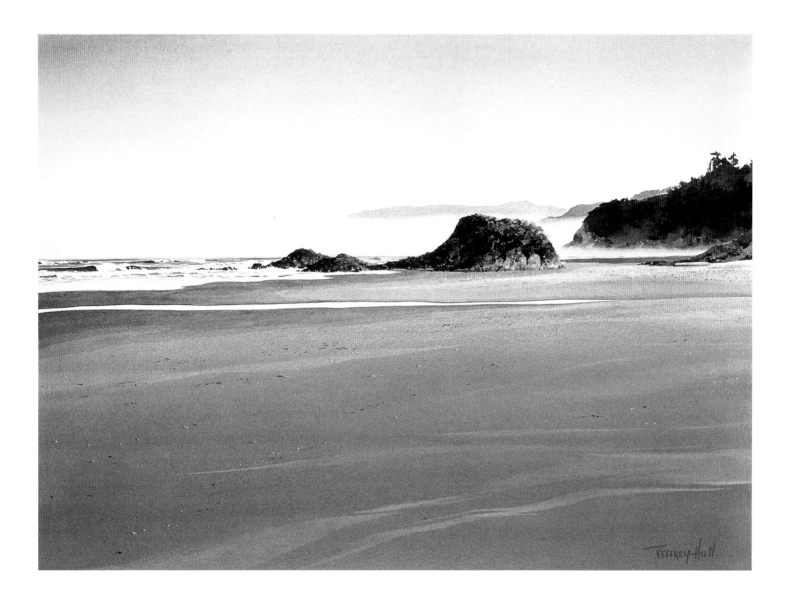

Jeffrey Hull

Early Light

22" x 30" (56 cm x 76 cm)
Transparent watercolor on Arches 140 lb. cold press paper

Sometimes all it takes is particular lighting to spark interest in a familiar subject. These conditions, combined with the composition of so much foreground sand, inspired this watercolor. A small bit of white was used for shells on the beach. As any painter knows, some paintings just seem to flow, resulting in works which are almost beyond our abilities. I'm on this beach nearly every day and, as I write this description in January, I still long for a summer morning like the one shown.

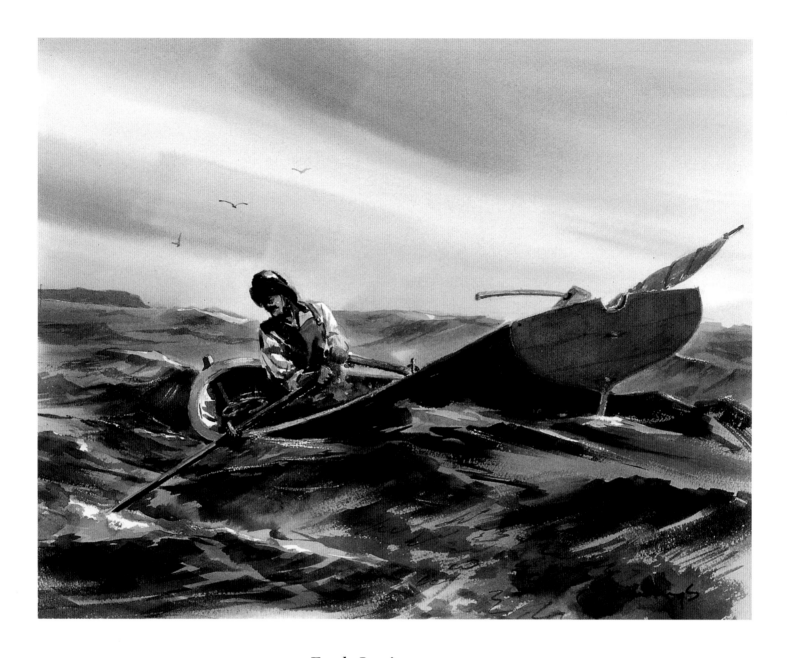

Frank Jennings

Mariner
22" x 24" (56 cm x 61 cm)
Watercolor on Arches 140 lb. cold press paper

Watercolor is always amazing, with as many advantages and limitations as any other medium. In my sixty-five-plus years of painting, I have not fully mastered it and I do not expect to. My preference for marine painting comes from being born close to salt water in a place where people depend on it for survival. The subject of the seaman, desperately rowing for land, is derived from watching fishermen performing their arduous daily chores in Newfoundland, Canada. Some of the chores were dangerous as well, especially in bad weather. I painted the scene using photos of the sea as a reference; the mariner was adapted from records on file.

Steve Andrus

W. Ashley

25.5" x 40" (65 cm x 102 cm)
Watercolor on Arches 260 lb. cold press paper

Steve Andrus has a varied maritime background. His home for over twenty years was on the Outer Banks, Nags Head, North Carolina. During that time, he sailed into hundreds of harbors, each one different and in a constantly changing atmosphere. He says that there is nothing better than to sail into and explore a new harbor. His present home is in landlocked Taos, New Mexico, surrounded by mountains, streams, and other Western settings, but, he says, "I still paint marine subjects." In this picture, there is an old gaff-rigged schooner, a trawler, and a modern sloop interlaced with many small tenders or dinghies. Each vessel is reflected in the waters of this calm harbor, which awaits the pending storm darkening the sky.

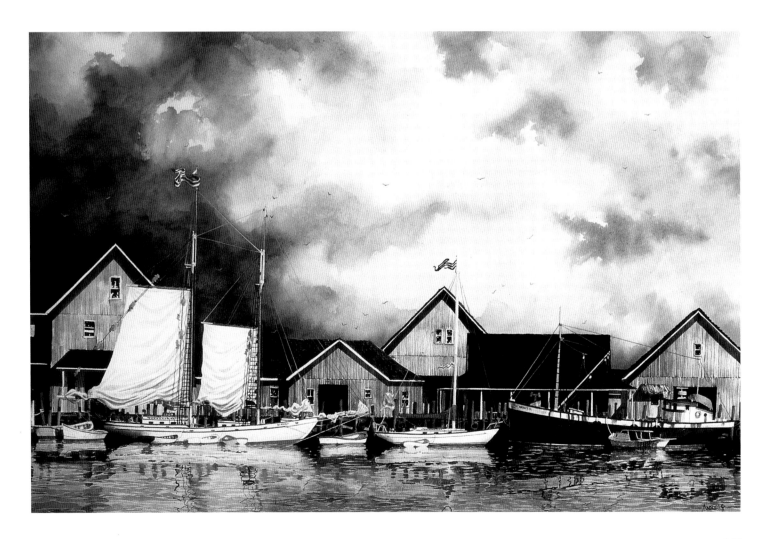

Frank Milauskas

Sunday Afternoon Fishing

22" x 30" (56 cm x 76 cm)

Watercolor on Arches 300 lb. cold press

I was lucky to find these two vintage fishing vessels at a dock in Provincetown, Massachusetts. Wood hulls will soon be gone from the nostalgic harbor scenes. Trying to create the colors and values with my first wash, I used a well-loaded one-inch brush to start the painting. A sprinkling of salt was used to reflect a weather-beaten hull.

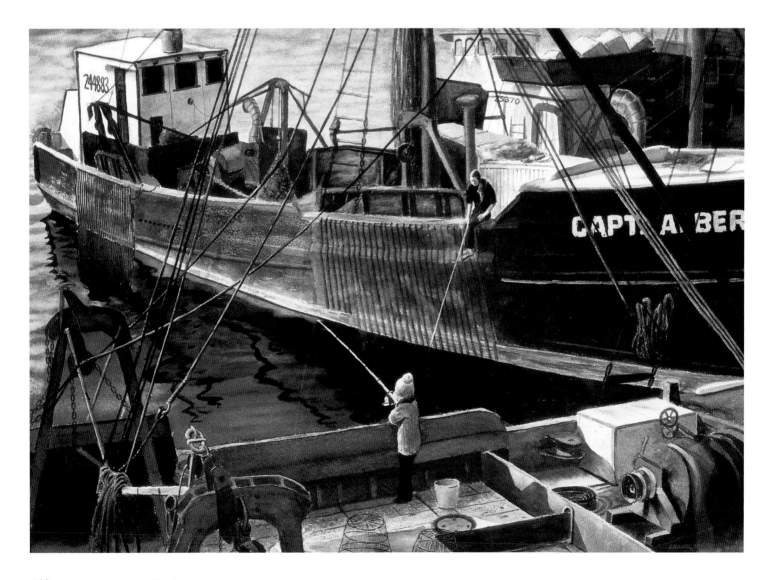

Ivan N. Kamalic

Fishermans Wharf

18" x 24" (46 cm x 61 cm)
Oil on Masonite board

This picture was painted from a setting in the harbor at Gloucester, Massachusetts. The late afternoon light was strong and fast moving. I used a venetian oil medium on smoothboard. This enabled me to work quickly using wet-in-wet to capture the light. As an art student/apprentice in Italy, I've studied the mediums and techniques of the old masters which I use in my painting.

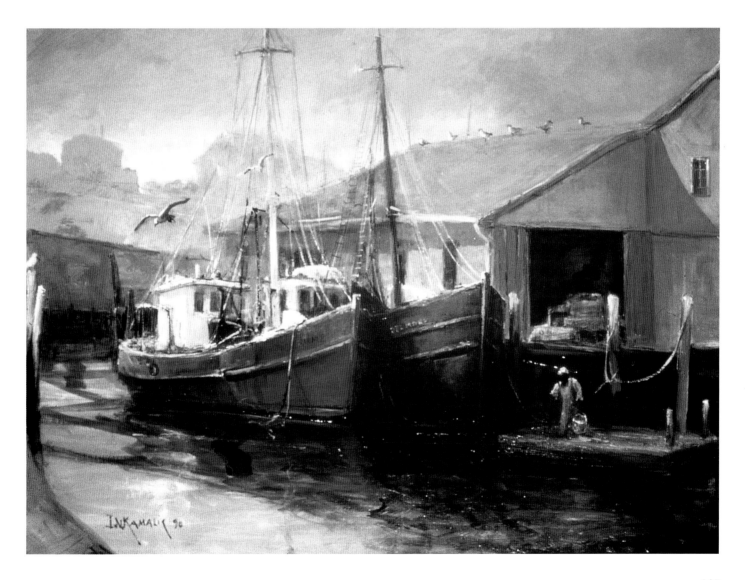

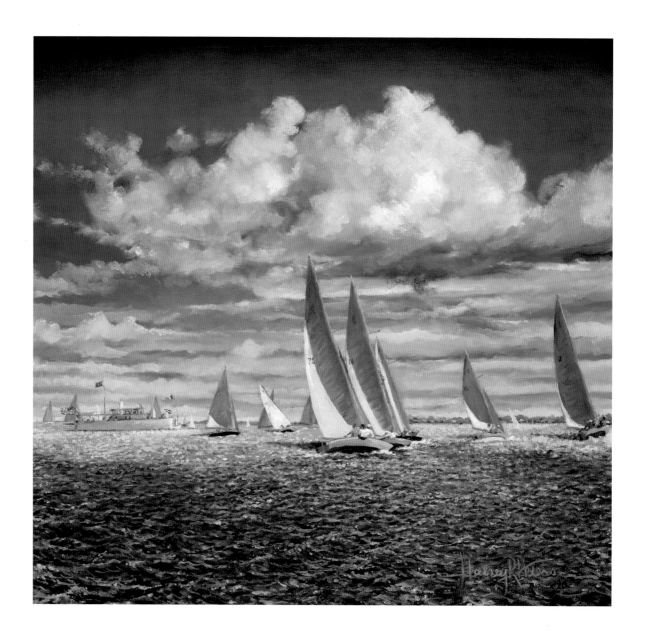

Halsey R. Peterson

Regatta — the Start
22" x 23" (56 cm x 58 cm)
Oil on Belgian linen canvas

Painted in 1990, this painting reflects happy memories of my early life in the mid to late 40s, when I sailed on Raritan Bay near Perth Amboy, New Jersey. The scene is set in October on a bright, clear, and cool day with a good breeze blowing—a perfect day for a race! The old committee boat was the *Aurora* built about 1917. It was used only on very special occasions.

Mary Alice Braukman

The Images of the Sea
22" x 30" (56 cm x 76 cm)
Acrylic and pastel on Crescent illustration board

Several years ago, I travelled the Gulf of Alaska on a cruise. I had a small art kit consisting of some 4" x 6" watercolor postcard papers and a small hand-held palette to capture the breathtaking scenery. The views passed by quickly, however, allowing me only a few minutes each to make quick little watercolors to capture the emotion of the moment. After returning home, I transferred a few of these instant paintings onto full-sized sheets of paper.

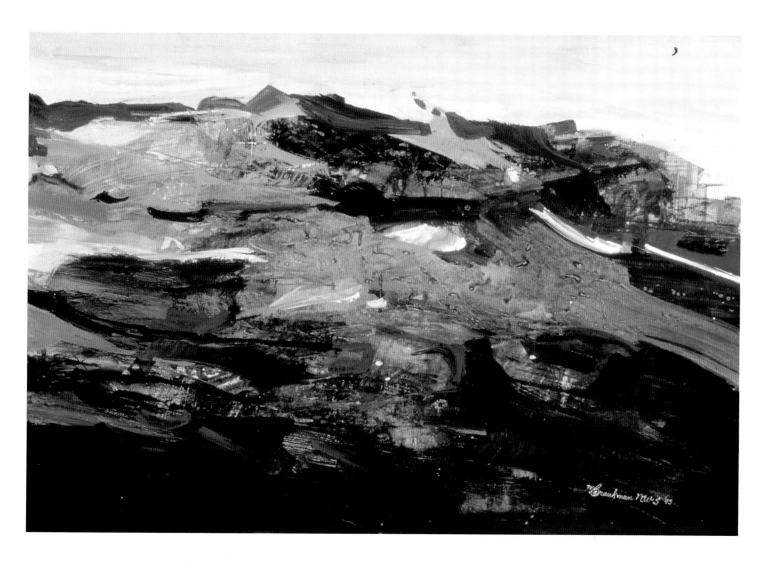

Herbert Rose

Curling Wave

15" x 22" (38 cm x 56 cm)
Watercolor on Arches 140 lb. cold press paper

A wave curling in around the point caught my eye. It repeated itself several times, allowing me to sketch the scene. The near silhouette of the trees on the left was adjusted to give a feeling of the breaking wave coming in close around the point. In the foreground, there was just a suggestion of beach or rocky shore to complement the mass of trees above. This picture was painted from my sketches and memory as a watercolor demonstration.

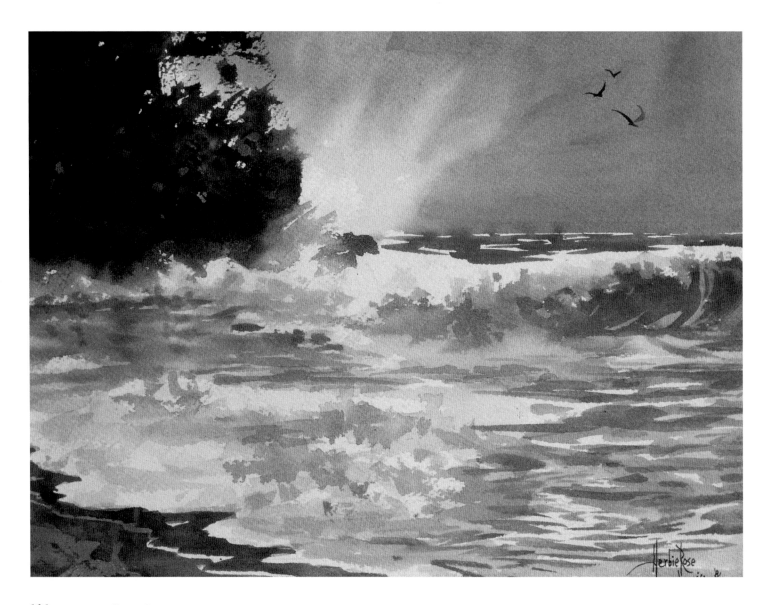

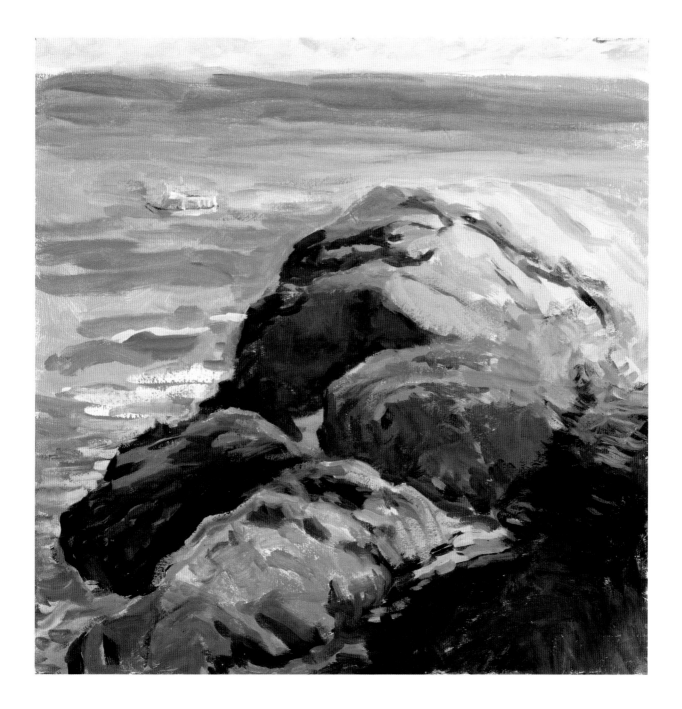

Lorraine Lans

Gull Rocks

16" x 16" (41 cm x 41 cm)
Oil on gesso-primed and sanded untempered ¼" Masonite

The spectacular shoreline of Monhegan Island, Maine, is my subject. Standing one hundred feet above the sea and looking down on gull rocks and a pounding surf on a windy day makes for a hair-raising experience. The challenge was to capture the rock shadows and the afternoon ferry as it came past on the "round the island tour." I weighted my easel with rocks to prevent it from blowing over the cliff in the fresh ocean breeze.

Loretta Krupinski

Spirit
22" x 32" (56 cm x 81 cm)
Oil on linen portrait canvas

Spirit, built in 1934, is a Malabar schooner designed by John Alden. With her gleaming 58-foot wood hull surging noiselessly through the waves, she creates a powerful image. It is fitting that the beauty of this period boat be preserved forever on canvas.

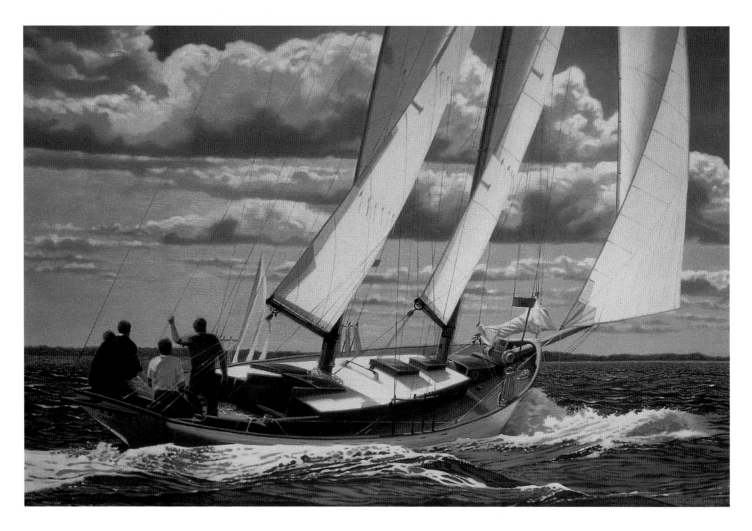

Martin R. Ahearn

Mist over Straightsmouth Island

21" x 29" (53 cm x 74 cm)
Watercolor on Arches 300 lb. cold press paper

This island is a view from the front of Ahearn's home at Gaps Cove, Rockport, Massachusetts. It is painted in watercolor with no opaques or special techniques used and was an award winner at the 1997 North Shore Art Association's summer show. This is a traditional scene of lighthouse buildings perched atop a wide expanse of rock. Worn smooth by countless winter storms, the dark, brooding, unmovable stone ledge dominates the foreground. Cool fog veils the lighthouse in pastel hues and steals away all detail and substance. This watercolor is a deceptively simple painting which exemplifies the medium.

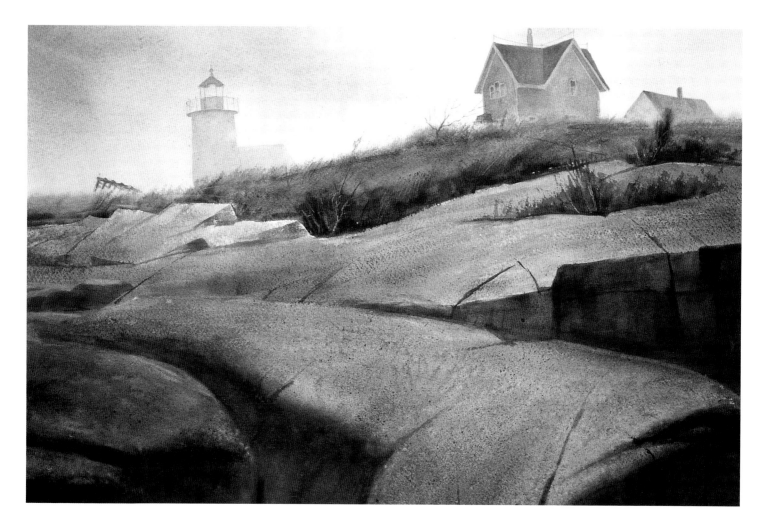

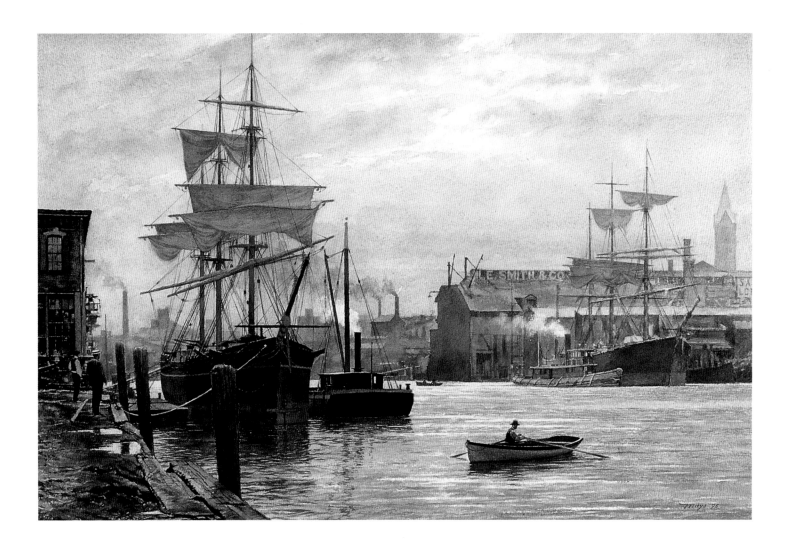

Victor Mays

Providence River—Early 20th Century

13.5" x 20.5" (34 cm x 52 cm)
Watercolor on Arches cold press paper

The sea played a key part in the settlement and growth of Rhode Island's capital. My painting shows the active shipping and the wharfage which lined the downtown river banks well into this century. The scene is composed from a variety of old photographs and city maps examined at the Providence Historical Society. My work focuses on coastal sail trade and ports of the nineteenth century and I enjoy researching my subjects in museums, libraries, and local collections.

J. Everett Draper

Highway to the Sea
15" x 22" (38 cm x 56 cm)
Watercolor on Arches paper

Going to sea is usually associated with ships or boats of some kind. This watercolor illustrates a unique way to go to sea. It is a typical sunlit picture of the activities on the highway leading out to the Florida Keys—the "Highway to the Sea."

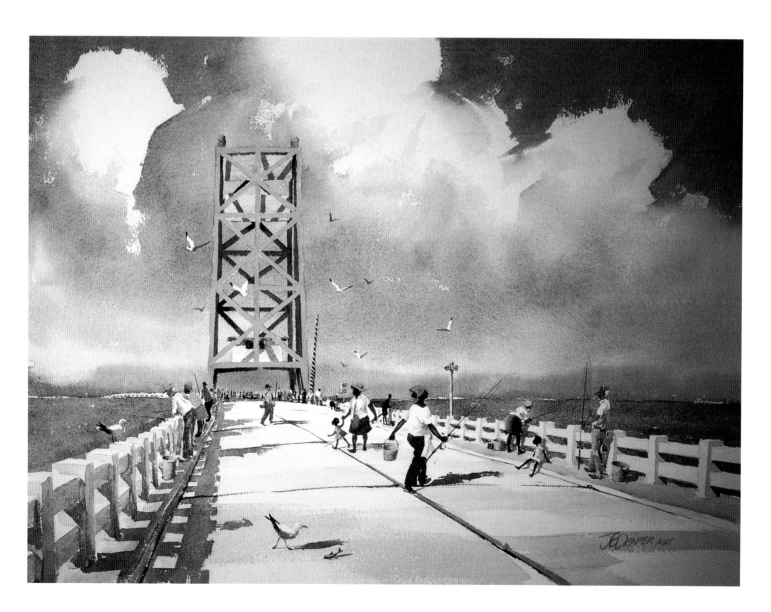

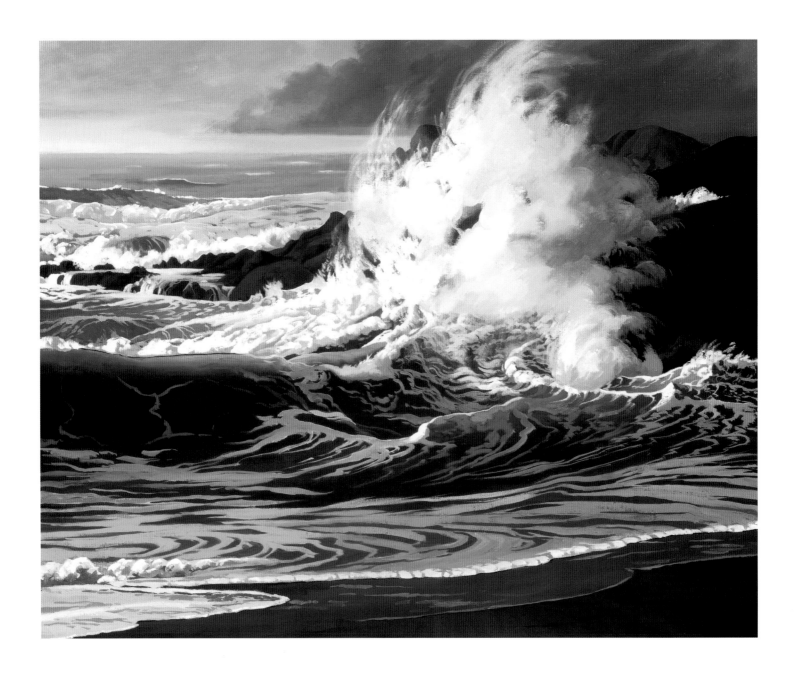

Helen West

Gathering Storm
24" x 30" (61 cm x 76 cm)
Oil on linen

This painting was inspired by a storm moving along the mid-Oregon coast. It is an area where the waves meet the basalt rocks with a tremendous force. In this scene, the power of the ocean is awe inspiring.

J. D. De Francesco

U. S. S. Frigate Constellation and L'Insurgente
18" x 24" (46 cm x 61 cm)
Oil on canvas

As a retired U.S. naval officer, I've always been interested in the age of sail, particularly the frigate battles from 1750 to 1815. All paintings are researched for historical accuracy from my extensive naval history library. Living on the coast of the Atlantic Ocean provides constant inspiration regarding all things nautical.

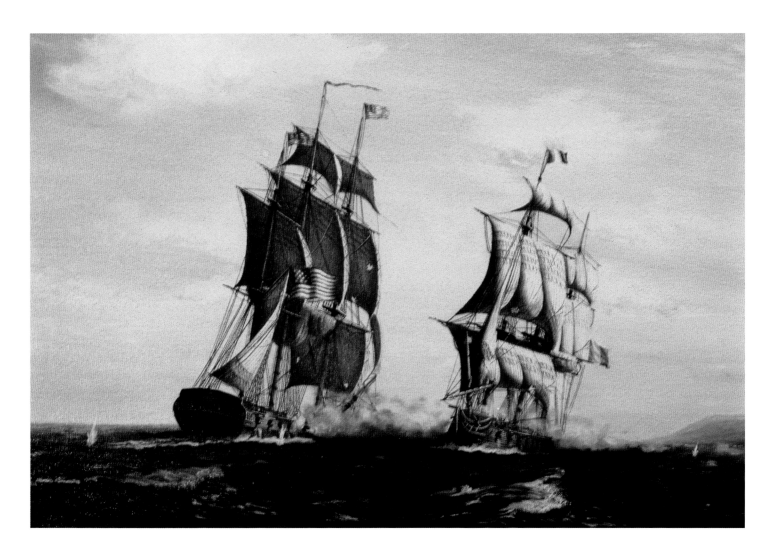

Kevin Taylor

Loading the Scrap
36" x 48" (91 cm x 122 cm)
Oil on gesso-primed Masonite hardboard

This subject was painted specifically for the ACTA Maritime Award Exhibition in Melbourne, Australia. Fifty paintings were hung from 260 entries. The painting was developed using color sketches and photographs. My intention was to construct a strong design and a color scheme which would help to express my reaction to the docks as a rather lonely, dehumanized place.

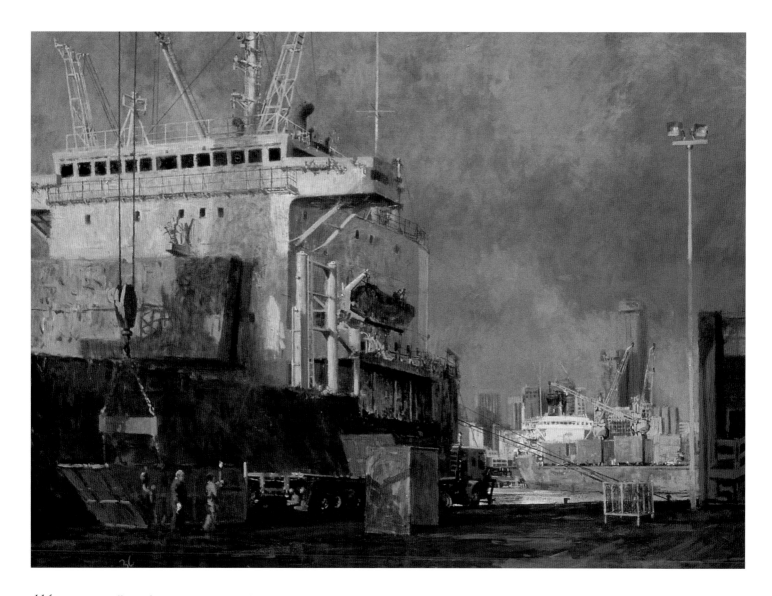

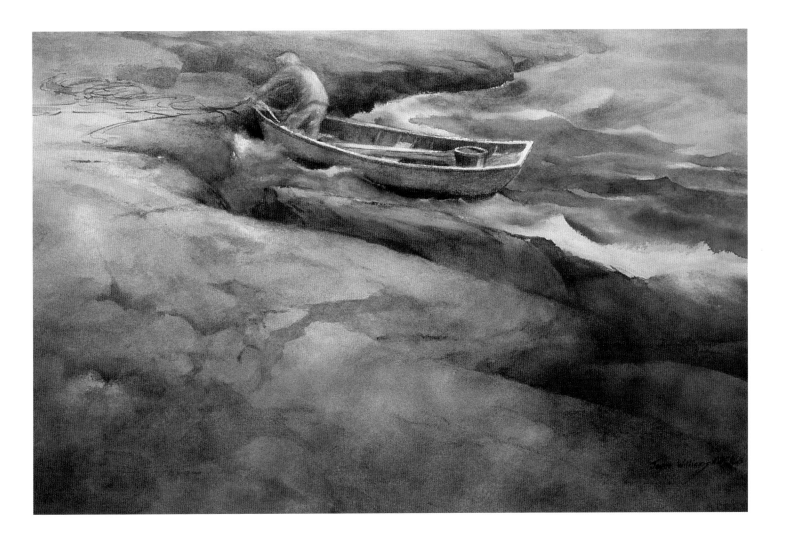

Joyce Williams

Storm Warning
22" x 30" (56 cm x 76 cm)
Transparent watercolor on Arches 300 lb. cold press paper

Living on the coast, I have observed scenes like this many times before or during a storm. I enjoy painting all types of marine subjects: different types of vessels, all kinds of marine weather, parts of boats, figures, and any objects connected to marine life.

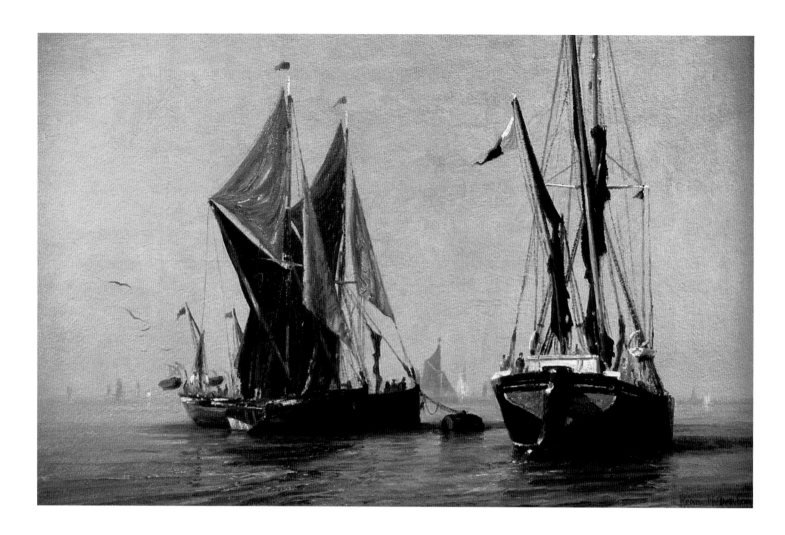

Kenneth Denton

Spritsail Barges: Early Morning
River Medway, England
20" x 30" (51 cm x 76 cm)
Oil on prepared panel

~~~~~~~~~~~~~~~~~

Spritsail rig barges are river-based, flat-bottomed cargo craft of the early nineteenth century. Only about twenty-five exist today and each year they race on the River Medway. There were about 600 of these craft in use when I was a boy in the 1930s. My interest in marine painting began with these beautiful craft and I am noted for paintings of them. The picture shows a fleet, just after sunrise, preparing for the morning Medway race which will begin at seven o'clock.

## Karol B. Wyckoff

**Wellfleet Fishing Boats**
22" x 15" (56 cm x 38 cm)
Transparent watercolor on Arches 300 lb. cold press paper

~~~~~~~~~~~~~~~~~

The tide was low and there was a soft mist in the salt air as I walked down to the Wellfleet fishing pier on Cape Cod, Massachusetts. Three vessels of the fishing fleet were tied up at the pilings and I knew they would be there a while, waiting the tide. The harbor had not been dredged for the larger boats. I grabbed my sketch pad, paints, and camera and captured these stately sisters as they were waiting for their crew and the incoming tide.

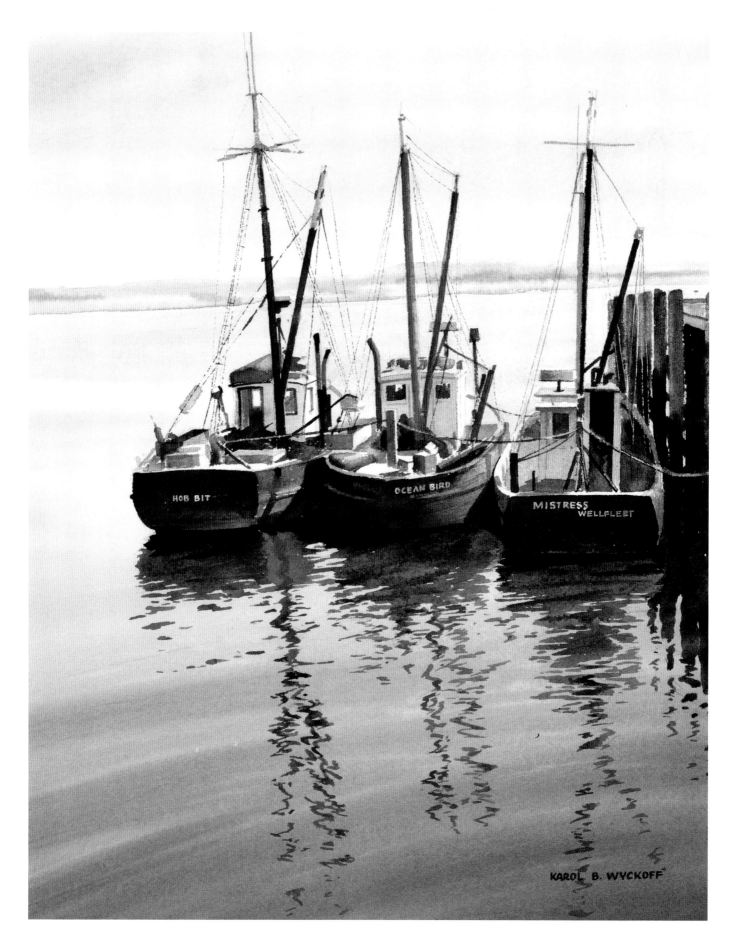

KAROL B. WYCKOFF

Jonathan Hotz

Gloucester Winter
30" x 40" (76 cm x 102 cm)
Oil on canvas

Gloucester is one of the few working harbors left in Massachusetts. It provides great subject matter for art compositions. In winter, the afternoon sun creates dramatic and intense light effects as it filters through the harbor.

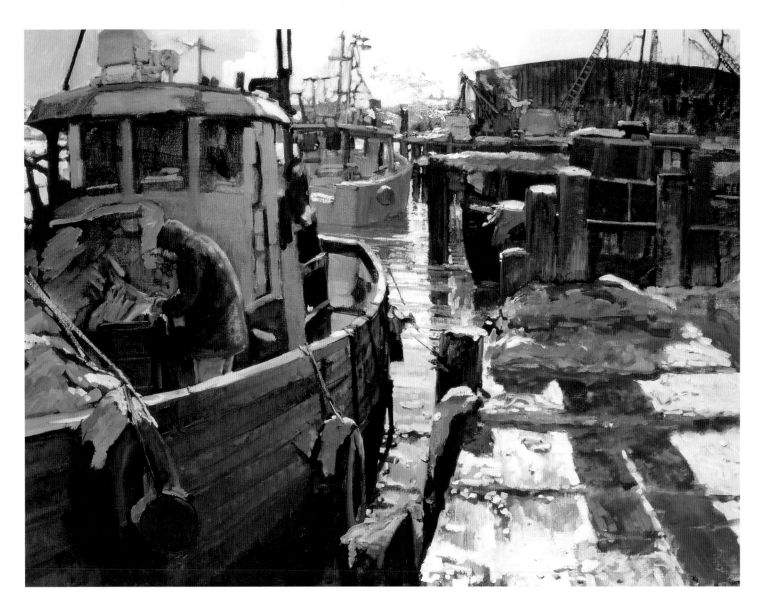

Martha Ingalls

Ten Pound Island
24" x 36" (61 cm x 91 cm)
Oil on canvas

Ten Pound Island is a landmark just outside Gloucester Harbor in Massachusetts. The lighthouse is a beacon marking the entrance to the harbor. It has been a favorite subject for many artists over the years.

Leonard Mizerek

Schooners at Sunset
17.75" x 21" (45 cm x 53 cm)
Oil on Windberg prepared panel

Painting for me involves the effects of light, and how it creates a mood or projects a certain feeling. I like the tranquillity of this scene, painted on site at the banks of Penobscot Bay in southern Maine. It is a romantic setting, where time seems to stand still. A bright sail catches the light and draws the viewer into the distance on the schooner's voyage towards the open sea. I wanted to convey a tranquil, almost dream-like setting. Subtle control of values and complementary color combinations were used to emphasize the golden cast of the sun, which set the mood for the painting.

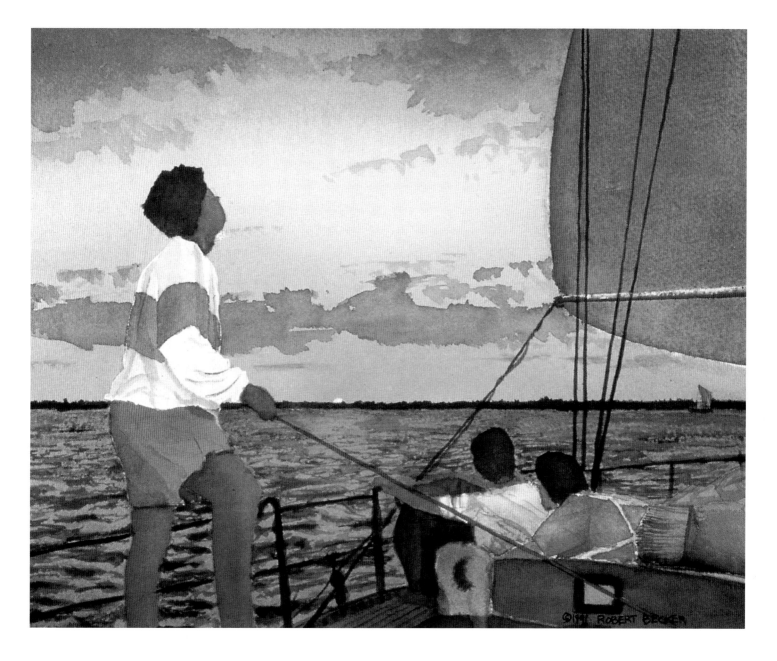

Robert Becker

Missing the Sunset
11" x 13.75" (28 cm x 35 cm)
Watercolor on Arches 140 lb. cold press paper

Flying a spinnaker requires absolute concentration on the part of the sail handler. Taking one's eyes off the sail for even a second can invite disaster by allowing the big baggy balloon to collapse. The view of a beautiful sunset on Long Island Sound is being lost by this sailor who is completely intent on the set of the sail. The name of the subject boat was *Montana* after the endless skies of that western state.

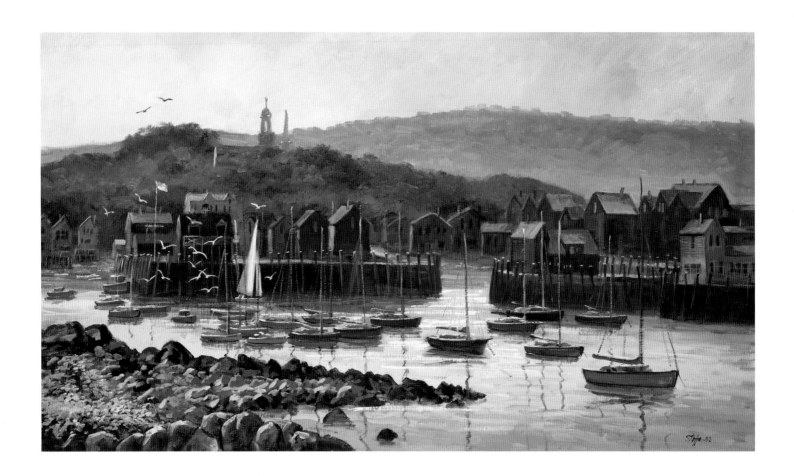

Michael Stoffa

View from the Headlands
24" x 30" (61 cm x 76 cm)
Oil on stretched linen canvas

I was intrigued by the light of the late-afternoon sun in the panoramic harbor at Rockport, Massachusetts. The stillness of the ocean and the lonely sailboat make a wonderful setting against the darker background. Each of the vertical planes is different in value.

Norma Jay

Sun Embraced
36" x 36" (91 cm x 91 cm)
Oil on linen canvas

With the exception of early summer, the Santa Barbara harbor generally has sunshine from dawn to dusk. This picturesque harbor, set against a backdrop of the Santa Inez Mountains, is a haven for hundreds of sport fishing boats. *Sun Embraced* is one of a series I have painted depicting the charming retreat. The painting was done with a palette knife.

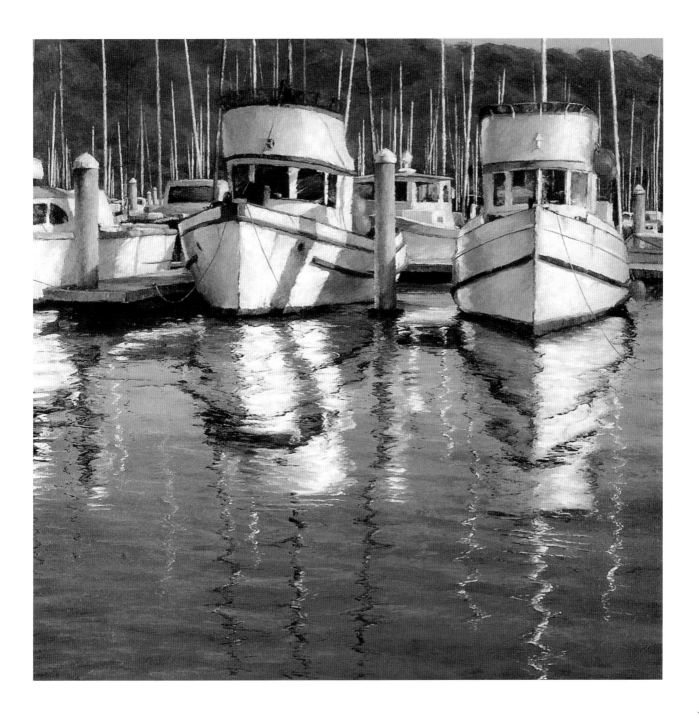

Ruth Karp

Into the Wind
15" x 22" (38 cm x 56 cm)
Watercolor on Arches 140 lb. cold press paper

Having lived in south Florida for nearly fifty years, the sea, surf, and sailing vessels have played an important part in my life. Just watching sailboats can be a very relaxing experience. I started painting these colorful boats many years ago and prefer to capture the essence and feeling of the subject matter rather than produce a detailed rendering. My methods include using a resist for the white lines and a razor blade to move the wet paint to create waves. My boat paintings are always done wet-in-wet in a loose and transparent manner.

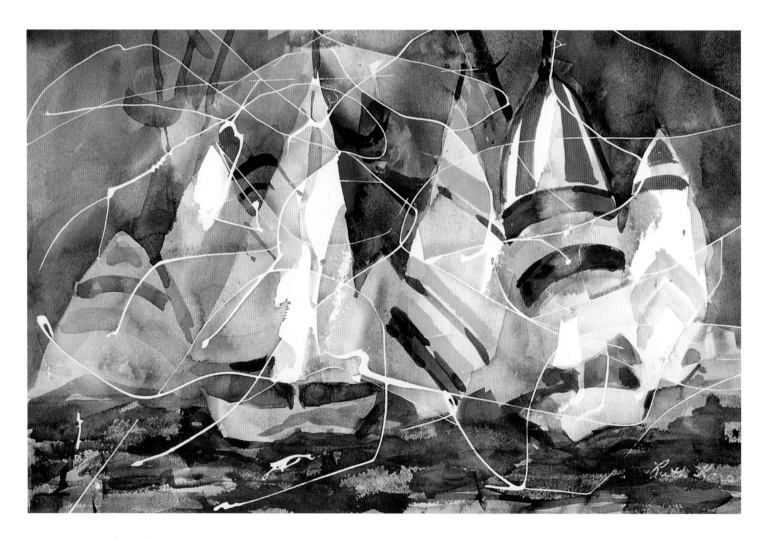

Madlyn-Ann C. Woolwich

Nautical Motif II
28" x 38" (71 cm x 97 cm)
Pastel on handmade pumice board

The harbor at Rockport, Massachusetts, is the location of this vibrant group of boats. No matter where one turns, there is natural subject matter. Painting this scene, I worked from sketches and a small watercolor loosely done. The boats turned ceaselessly in the currents made by other boats and the wind. I used primary colors to energize the image. The original colors were dull. Complementary and analogous colors are painted in acrylic beneath the pastel layers.

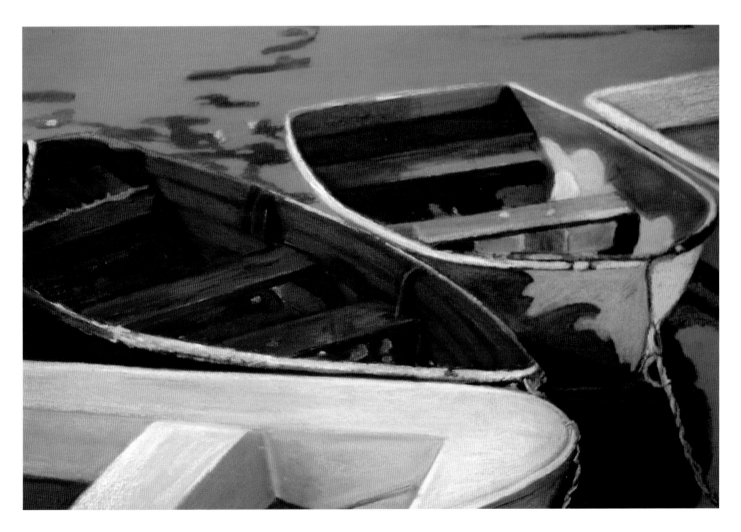

Neil Adamson

Oyster Beds

16" x 30" (41 cm x 76 cm)
Acrylic on Strathmore high surface illustration board

This picture was painted at a little fishing village on Florida's west coast. A very low tide left the oyster beds partly exposed. I was drawn to the dark abstract shapes of the beds that were rich in texture and color. They were in contrast to the light calm shapes of the water. I felt that the realistic pilings, ropes, and boat made a great scene.

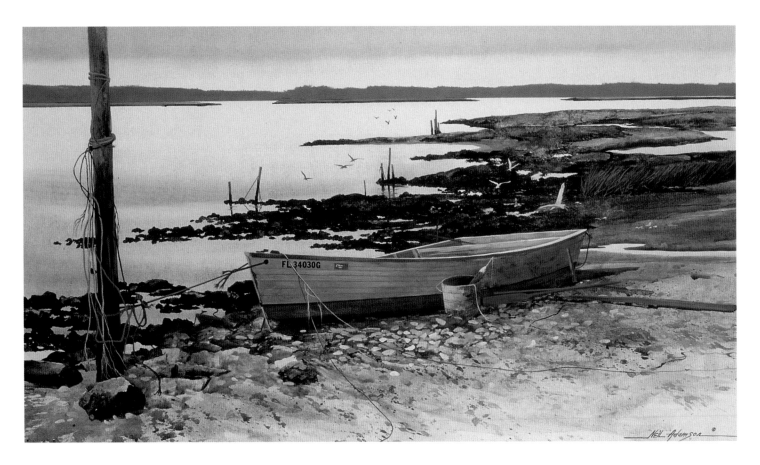

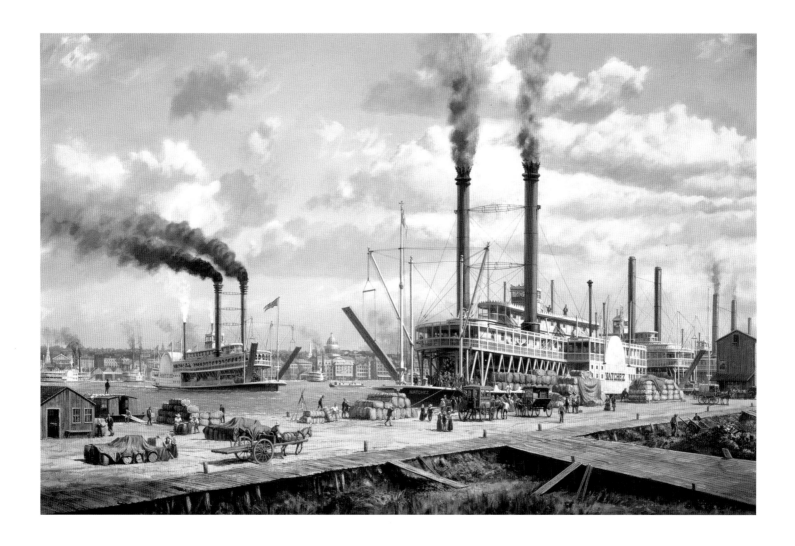

Roy Cross

New Orleans in the 1870s

32" x 50" (81 cm x 127 cm)
Oil on canvas

More than fifty years of study and practice in the painting of historical maritime scenes has made Roy Cross one of the finest artists of this particular genre. Roy's painterly style has a rhythm that speaks of his love and understanding of the subject. We will never see an historical harbor or other seaside area as it was over one hundred years ago, but with Roy's help and a bit of the imagination that lingers in the hearts of all of us who love the sea, we can experience the ship's movement, the brush of the wind, and the smell of the tar. In this picture, Roy takes us back to the old port of New Orleans, at the base of the great Mississippi River, with its nostalgic river boats and busy dock scenes.

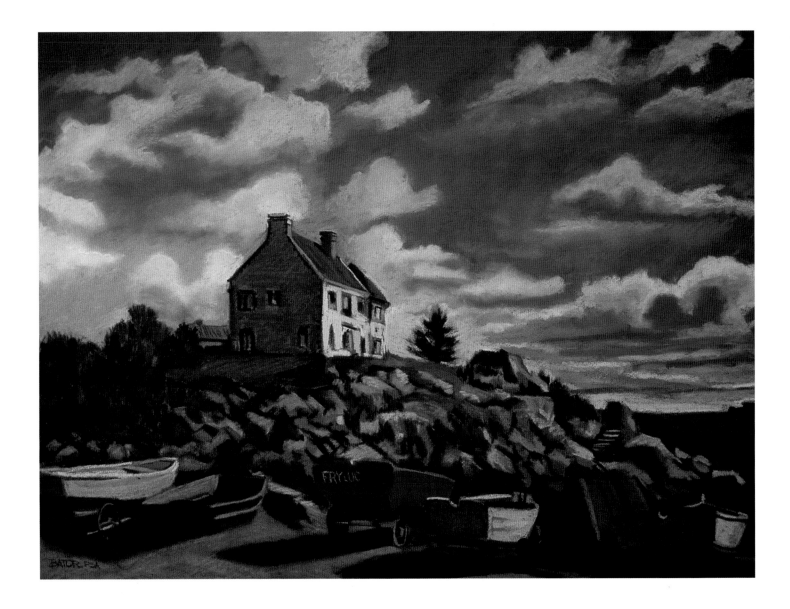

Martha Bator

Ponte du Chateau
26" x 35" (66 cm x 89 cm)
Pastel on four-ply museum board prepared with gesso
and pumice

~~~~~~~~~~~~~~~~~~~~~~~

During a visit to the northern coast of France in
Brittany, the bright blue sky was filled with
beautiful fluffy clouds. Below there were
brightly colored boats and an intriguing house
on a rocky hill. I could not resist capturing the
scene with my pastels. I also loved the cast
shadows and the interesting shapes.

## Joanna Calabro

### *Rockport Harbor*
16" x 12" (41 cm x 30 cm)
Oil on linen canvas

~~~~~~~~~~~~~~~~~~~~~~~

The incentive for my painting, *Rockport Harbor*,
was the early morning sunlight on the harbor and
the beautiful reflections on the water. The ever-
changing light on Cape Ann waters, the children
playing on the beach, and the many fishing boats
have been a constant inspiration to me.

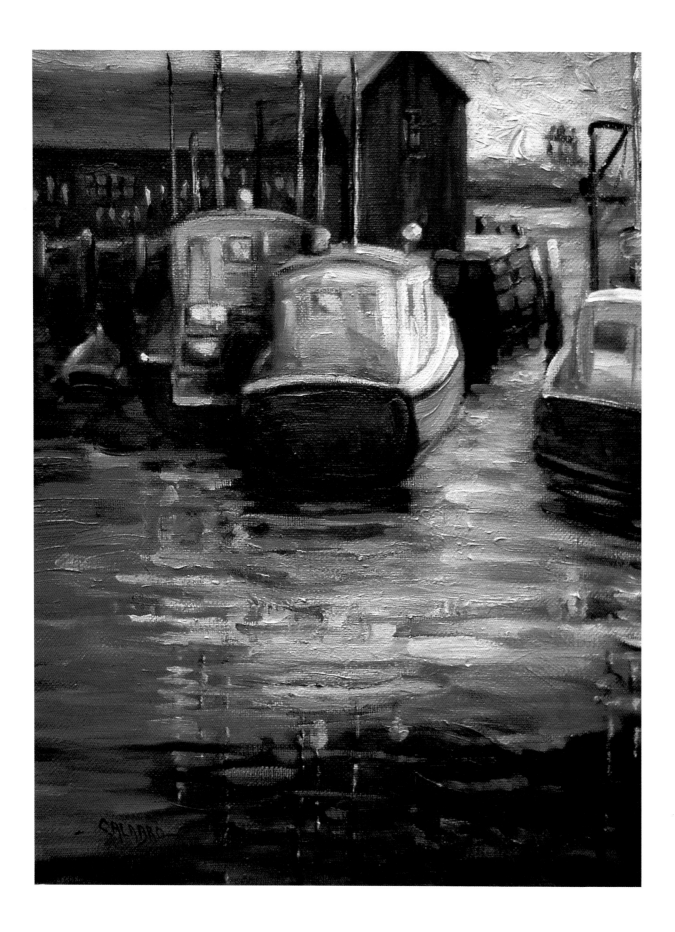

Margaret Laurie

Rockport Harbor

25.5" x 30.5" (65 cm x 77 cm)
Watercolor on Arches 260 lb. paper

The harbor at Rockport, Massachusetts, is an exciting location to paint the marvelous movement of boats and water. I specialize in marine paintings that not only capture the beauty of the ocean, but also show its vibrant force as crashing waves dominate the scene. This painting, *Rockport Harbor*, had to be drawn well, then painted as loosely as possible in order to have movement. In most of my paintings, the sky is painted with an atmospheric quality. A dark pattern is introduced early in the composition to claim the lights and set a value sequence. The shadows in my paintings are very important.

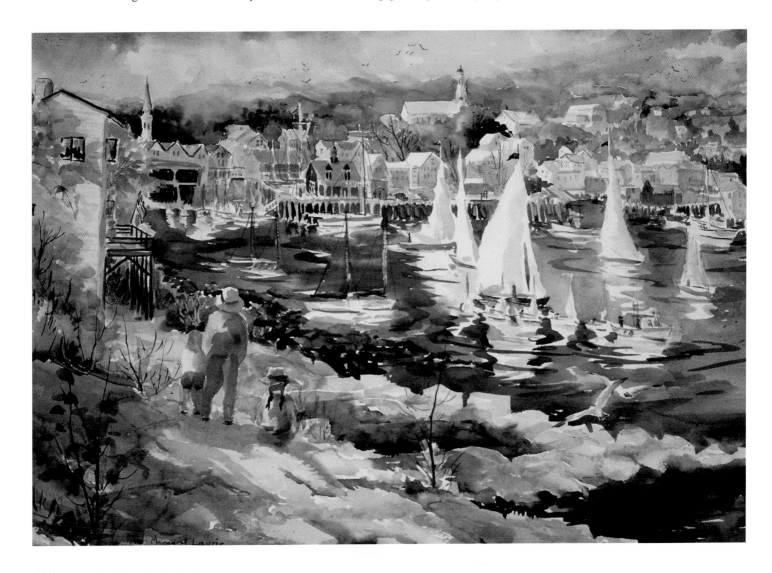

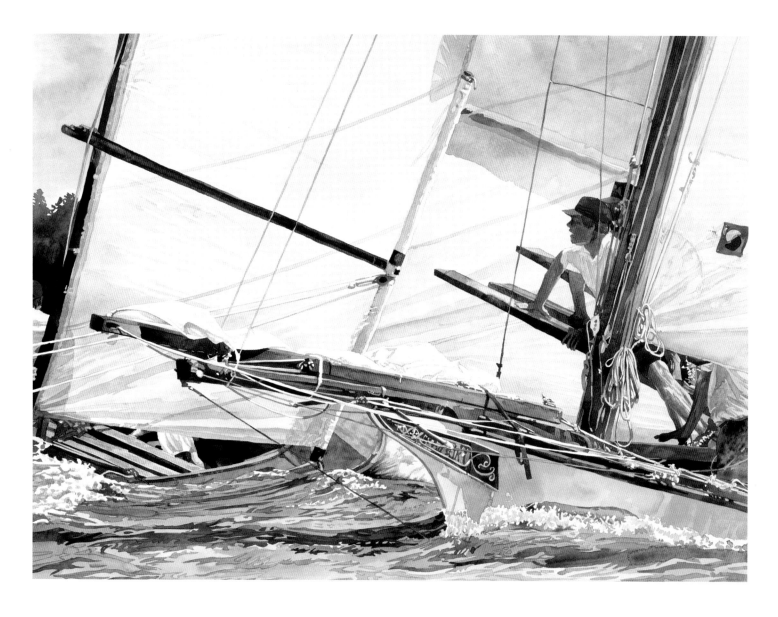

Marc A. Castelli

Tight Quarters on the Chester/Island Lark
22" x 30" (56 cm x 76 cm)l
Watercolor on Fabriano D'Artistico 140 lb. hot press paper

Marc Castelli has raced various sailboats for twenty-one years. During that time he has photographed, drawn, and painted many of them. His pictorial views speak of an intimacy that results from lengthy and dedicated exposure to the sport. Compositions that dwell on parts of boats, imply the boat, or offer views only a person on board would see are his specialty. This watercolor portrays an exciting moment of a group of racing sailboats in close quarters.

James D. Iams

City of Richmond
22" x 30" (56 cm x 76 cm)
Watercolor on Winsor & Newton 140 lb. hot press paper

The *City of Richmond* is seen here leaving Baltimore for an overnight run to Norfolk, Virginia. The steamer went out of service around 1954. I enjoy painting period pieces; however, most of my current works are modern ships and skipjacks of the Chesapeake Bay region.

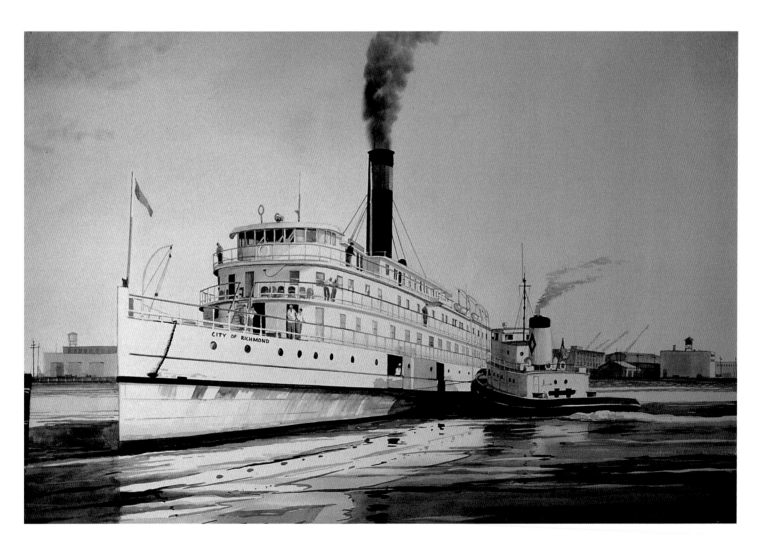

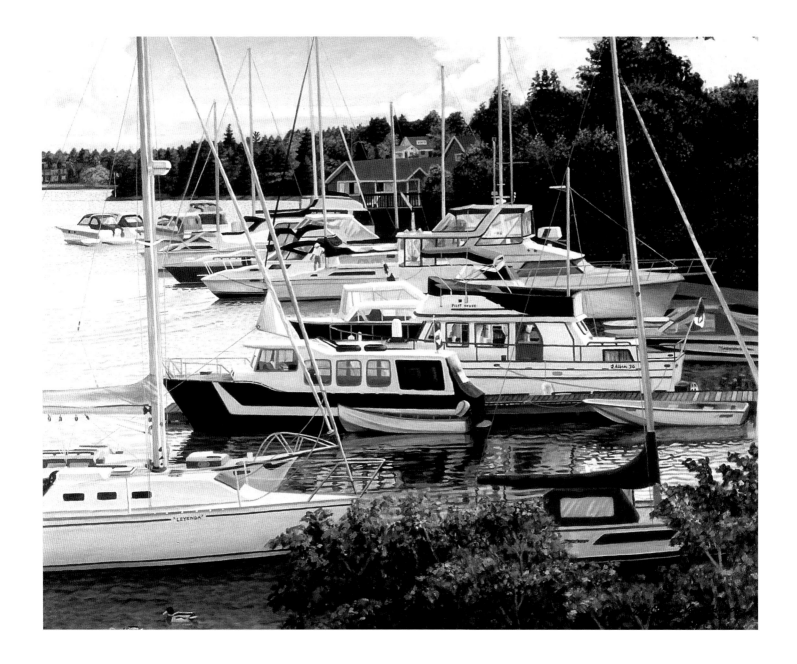

Karen Carter Van Gamper

Marina at Tobermory
30" x 36" (76 cm x 91 cm)
Oil on canvas

Tobermory, at the tip of the Bruce Peninsula in the Canadian waters of Lake Huron, marks the entry to Georgian Bay and the north channel of the lake. It is a strategic stopover for boaters who sail and cruise the northern islands. The two challenges here are the composition, with its layers of boats, and the three-dimensional effects created by shadows and highlights on the white surfaces. The perspective of the scene hinges on proportional relationship between the boats in the foreground and the others in the distance. The illusion of depth also depends on many shadings used to portray the contours of the white hulls. Bright sunlight reflects from the right and from behind the boats. This puts the surfaces facing us in shadow. The brightness of the day creates a soft glow within the shadowy area.

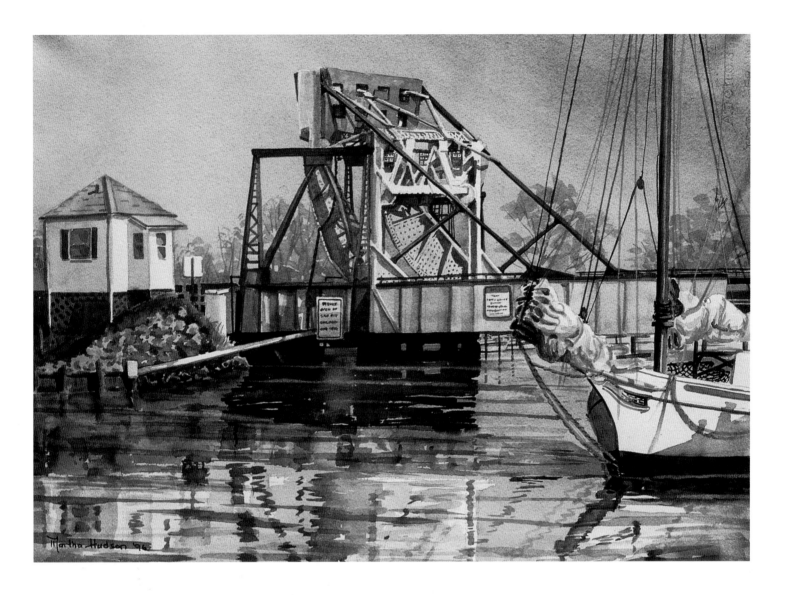

Martha Hudson

Knapps Narrows Bridge
15" x 20" (38 cm x 51 cm)
Watercolor on Arches 140 lb. paper

I have made several paintings of this bridge. This time, the work was commissioned. The old cantilever drawbridge is allegedly the busiest in the world. It saves boaters many miles since it cuts through the middle of a long peninsula at Tilghman Island. Currently, a new bridge is under construction and the old one will be removed and installed as an entrance to the Chesapeake Bay Maritime Museum at St. Michaels, Maryland.

Joan Colt Hooper

A Summer Afternoon
22" x 28" (56 cm x 71 cm)
Oil on stretched linen

This is the first in a series of "Shore to Sea" paintings done in analogous colors. I decided to play with non-natural colors using a technique of placing one hue alongside or against another to bring out a vibrancy. Living in Marblehead, Massachusetts, I am always looking from land to sea, which means looking at the ocean and boats through trees, between rocks, and over fences. Cruising and sailboat racing have always been a part of my life.

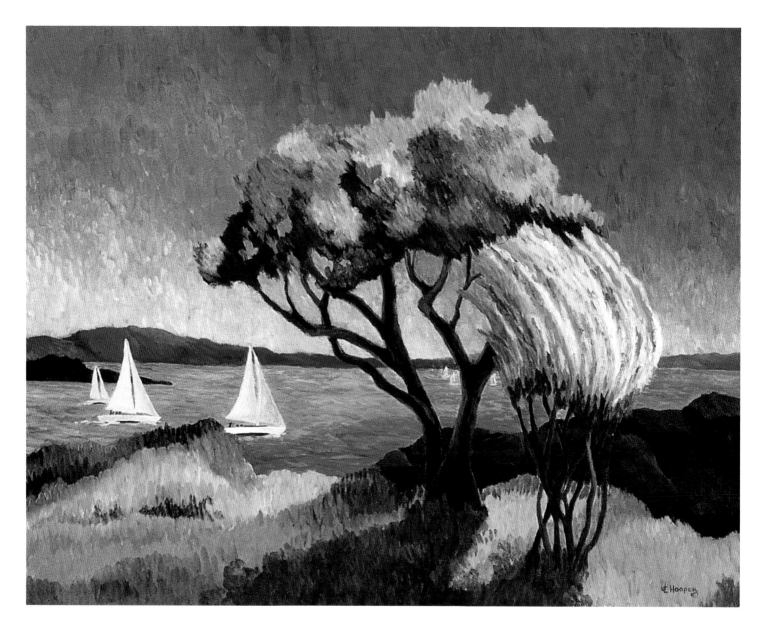

Robert Lovett

Loading Ships — Freemantle

10" x 14" (25 cm x 36 cm)
Watercolor on Arches 300 lb. rough paper

I liked the simple design of this subject. The main elements (ships, jetty, and buildings) were all held together in one dark horizontal mass thrusting across the picture. The vertical lines of the cranes, masts, and funnels provided contrast of direction. Rough paper was used to advantage to suggest the sunlight sparkling on the disturbed water.

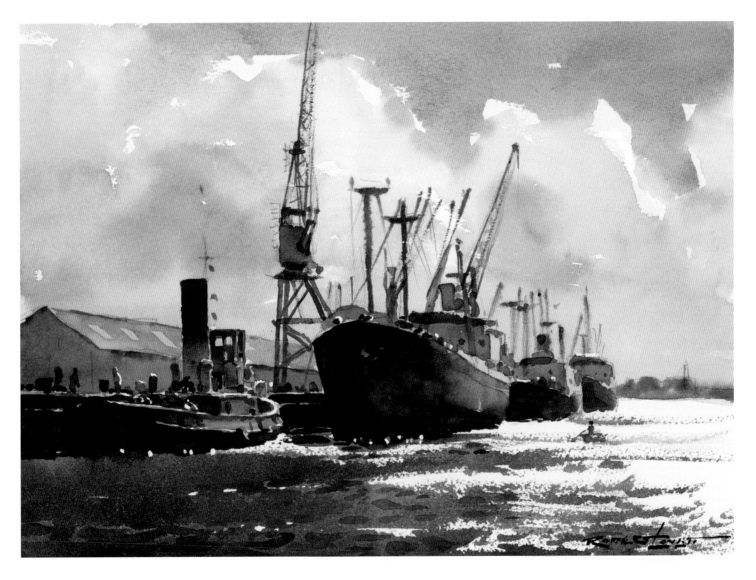

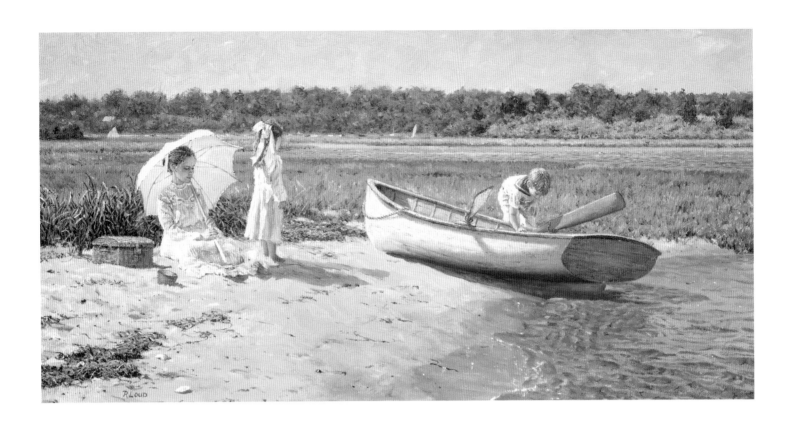

Richard K. Loud

Picnic, Westport River
23" x 38" (58 cm x 97 cm)
Oil on canvas

Growing up on the Adams Shore section of Quincy Bay in Massachusetts, Richard Loud cannot remember a time when his life did not revolve around boats. As the son of a master shipwright, he was exposed early in life to the complexities and beauties of boat design and construction. This early training and passionate love for sailing vessels are evident in his paintings today. He has a thorough understanding of a wide variety of vessels and sea conditions, and has developed a unique painterly feeling for light and atmosphere.

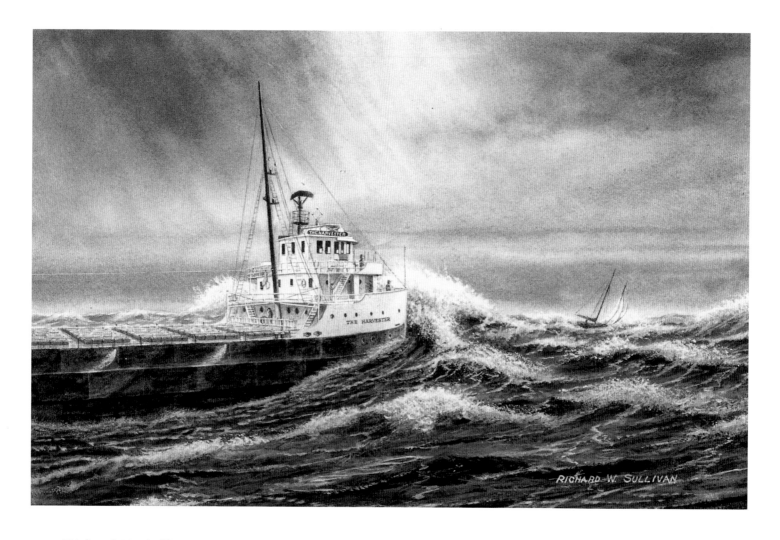

Richard W. Sullivan

Fair Weather Ahead

11" x 17" (28 cm x 43 cm)
Watercolor and acrylic on Arches 300 lb. cold press paper

It was late fall in 1945. I was a sixteen-year-old deck watchman aboard the steamer, *Charles M. Schwab*. We had just passed through rough weather when I was called to the pilothouse to answer the radio-telephone. My father, the third mate on a passing ship named *Harvester*, was on the phone. Looking out a portlight, I saw *Harvester* passing in close quarters. We were so close that I could see him talking to me on the phone in their pilothouse. Both carriers were going to the same loading dock in Superior, Wisconsin, where we met a few hours later. This painting shows his ship pulling ahead and leaving us in the wake.

Bruce Turner

Rockport Shores
8" x 16" (20 cm x 41 cm)
Oil on Masonite

Long Beach in Rockport, Massachusetts, has been a place of inspiration and good spirit for myself and anyone I know who has visited its shore. The coolness of the north Atlantic blue relieves us of the inland heat, and makes a wonderful contrast of the ongoing activity of the colorful sunlit bathers along the sea's edge.

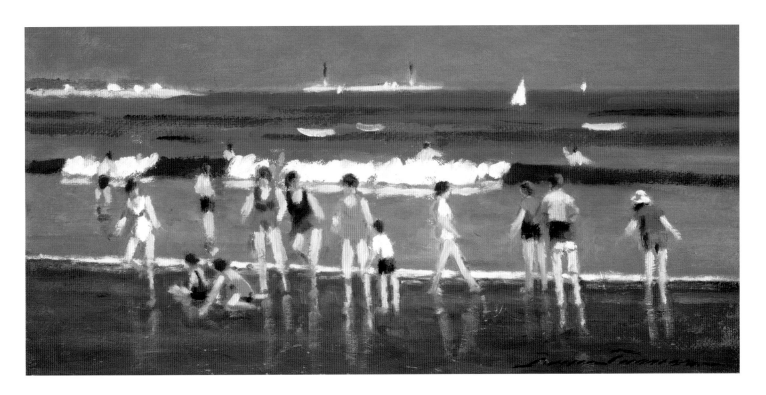

A Compilation of Art Terms and Techniques

bristol board a paperboard with a smooth surface. It is usually available with a plate or vellum finish and in a variety of thicknesses.

casein a paint that is precipitated from milk and other additives

gesso a sealer made of inert pigments such as chalk, whiting, or plaster of Paris mixed with aqueous binders; used to prepare a surface for water or oil-based paints

glazing the application of a thinned, transparent coat of paint which, when applied over a previously painted area, dries and allows the undercoating to show through

gouache watercolor paint mixed with opaque pigments to give it weight and body, like oil or acrylic paint, only duller

masking applying paint to a surface that has been covered with tape or another medium so that when the paint has dried, and the tape is removed, the undercoating shows through unaffected by the new layer of paint

mixed media artwork created by using a combination of various materials, i.e., different types of paints and surfaces used in conjunction with each other on the painting

pastel colors made by molding dry pigment and a binding medium into sticks, comparable to blackboard chalk

pigment a finely ground substance that is added to a base to give color

tempera a painting medium made by mixing ground pigment with a binding agent (such as egg, or another oily, fatty, waxy, or resinous substance) and diluted with water

wash a coating of paint

wet-in-wet/wet-on-wet to paint into an already-wet surface

A Compilation of Nautical Terms

beam the maximum width of a boat

belay to secure a line to an anchoring object

block a wooden or metal case which houses one or more pulleys

bollard a large fixture located on a docking platform and used to secure a mooring line

boom a horizontal beam or spar to which the bottom of a sail is attached

bow the forward or front end of a boat

bowsprit a large spar projecting from the bow of a vessel; most common on sailboats

cleat a metal or wood fixture designed to secure a line wrapped around it

forecastle the forward part of the upper deck of a ship; or a cabin in the bow of a ship usually used as crew's quarters

gaff a spar on which the top of a sail is secured

halyard a line used to raise a sail

jib the foremost sail on a sailboat; there can be one or many overlapping

keel the main structural element of a boat that extends longitudinally along the center of its underside

mainsail the principal sail on a boat, and normally the largest

mast a vertical pole rising from the deck or keel of a ship holding up the yards, booms, and sails

mizzen sail the aft or rear sail on a boat

rigging fixed rigging is permanent wires, chains, or ropes holding up the masts; running rigging is flexible and is used adjusting booms and sails

rubrail a protruding strip running the length of a boat that protects it from damage during docking

rudder a flat fore and aft vertical panel hinged on the rear of a boat to provide steerage

shroud fixed rigging running crossways on a boat

spar a general term for any of the beams on which sails are set

spinnaker a large parachute-like sail on the front of a sailboat used when running before the wind

stay fixed rigging running fore and aft supporting the mast

stern the back end of a boat

topside the portion of a boat that is visible above the waterline

transom the planking across the back of a boat forming the stern

yardarm a crosswise beam on a ship to which the top and bottom of a square sail are attached

Below is a gallery of some of the more recognizable types of small sailing vessels.

Gaff Rig
Sloop

Schooner

Gaff Rig
Catboat

Sloop

Ketch

Yawl

Neil Adamson 126
7089 South Shore Drive
South Pasadena Isle, FL 33707

Martin R. Ahearn 109
62 Marmion Way
Rockport, MA 01966

Steve Andrus 101
P.O. Box 1334
749 Ranchitos
Taos, NM 87571

Catherine Arnera 83
Rue du Vieux-Pressoir, 7
1297 Founex, Vaud
Switzerland

Dimetrious Athas, ASMA, ISMP 14
P.O. Box 15
Nahant, MA 01908

John M. Barber 90
5812 1/2 Grove Avenue
Richmond, VA 23226

David Bareford 80
c/o Quester, Inc.
P.O. Box 446
Stonington, CT 06378

Nina Barnes 92
Old Coast Guard Station
Tokeland, WA 98590

Martha Bator, PSA, KA 128
3432 Stratfield Drive NE
Atlanta, GA 30319

Robert Becker 121
1961 Woodpecker Court
Walnut Creek, CA 94595

Eric Bell 46
3015 15th Avenue
Roxboro, Quebec
Canada H84 2X1

Robert T. Blazek 70
143 Goodhouse Road
Litchfield, CT 06759

Mary Alice Braukman, NWS 105
636 Nineteenth Avenue NE
St. Petersburg, FL 33704

Rose Weber Brown 72
10510 Winchester Court
Fort Myers, FL 33908

John S. Caggiano 89
4 Main Street
Rockport, MA 01966

Joanna Calabro 129
32 Main Street
Rockport, MA 01966

Phil Capen 10
560 Southeast 27th Lane
Homestead, FL 33033

Donald R. Carmichael 37
860 Stewart Street
Englewood, FL 34223-2844

Marc A. Castelli 131
Dam Creek Farm
7098 Wilkins Lane
Chestertown, MD 21620

Wanda Coady 34
14 Meridian Terrace
Paxton, IL 60957

Jack Coggins, ASMA, PSA. 82
P.O. Box 57
Boyertown, PA 19512

Carolyn Councell 13
420 Riverside Drive
Pasadena, MD 21122

Roy Cross 127
P.O. Box One
Salem, MA 01970

William R. Davis 68
P.O. Box 2152
Hyannis, MA 02601

J. D. De Francesco 113
Milestone, 5A Fernlea Terrace
St. Ives
Cornwall TR26 2BH
England

Donald Demers 57
457 York Street
P.O. Box 1024
York Harbor, ME 03911

Kenneth Denton, RSMA, FRSA, ISMP 116
Priory Farm Lodge, Sporle
Kings Lynn
Norfolk PE32 2DS
England

J. Everett Draper, AWS 111
20 Pointe Vedra Circle
P.O. Box 12
Pointe Vedra Beach, FL 32004

Lorraine E'drie 88
1809 1/2 West Bay Avenue
Newport Beach, CA 92663

Cynthia Eastman-Roan 27
4355 Redwood Drive
Oakley, CA 94561

Bill Ellsworth 56
1900 Pine View Avenue
Virginia Beach, VA 23456-3939

Gerald J. Fritzler 98
1051 50 Road 1
Box 253
Mesa, CO 81643-0253

L. L. (Lee) George 93
P.O. Box 514
Seward, Alaska 99664-0514

Helmut Gerth 53
87 Pointe-Claire Avenue
Pointe-Claire, Quebec
Canada H9S 4M6

Don Getz 76
2245 Major Road
Peninsula, OH 44264-9626

William Gilkerson 66
149 Martins River Road East
RR 2 Mahone Bay
Nova Scotia
Canada B0J 2E0

Catherine Gill 22
6218 20th Avenue NE
Seattle, WA 98115

Walt Gonske 23
P.O. Box 1538
Taos, NM 87571

Lorraine J. Grinnell 95
1779 Shore View Drive
Indialantic, FL 32903

Carl Gustafson 15
24 King Street
Rockport, MA 01966

Robert Hartigan 60
5645 North Tuttle Avenue
Sarasota, FL 34243

Doug Higgins 79
26 Camino Cielo
Santa Fe, NM 87501

Joan Colt Hooper 135
20 Mill Pond
Marblehead, MA 01945

Jonathan Hotz 118
71A Main Street
Rockport, MA 01966

Martha Hudson 134
9104 Mallard Point Court
McDaniel, MD 21647

Jeffrey Hull 99
P.O. Box 272
Cannon Beach, OR 97110

Amanda J. Hyatt 45
25 Culzean Crescent
Highton, Victoria 3216
Australia

James D. Iams 132
1604 Kuntz Avenue
Lutherville, MD 21093

Martha Ingalls 119
5 Suntaug Street
Lynnfield, MA 01940

Irene Jarrow Jaworowski 59
2 Barkley Lane
Palmyra, VA 22963

Norma Jay 123
13910 Southeast Hampshire Way
Clackamas, OR 97015

Frank Jennings 100
1018 North Lime Avenue
Sarasota, FL 34237-3512

Ivan N. Kamalic 103
2939 Brighton 5th Street
Brooklyn, NY 11235

Michael B. Karas 28
P.O. Box 56
Sandy Point, ME 04972

Ruth Karp 124
44 Bal Bay Drive
Bal Harbor, FL 33154

William C. Kavanek 30
130 Stuart Road East
Bridgewater, CT 06752

Scott Kennedy 65
307A East Aliso Street
Ojai, CA 93023

R. Clay Kent 41
900 West Eau Gallie Boulevard
Melbourne, FL 32935

Harold Kloongian 96
46 Juniper Hill Road
Waltham, MA 02154

Loretta Krupinski 108
6 Coach Drive
Old Lyme, CT 06371

Lorraine Lans 107
P.O. Box 534
Stonington, ME 04681

Charles Laskey 29
175 Southeast St. Lucie Boulevard,
#C50
Stuart, FL 34996

Margaret Laurie 130
4 Blake Court
Gloucester, MA 01930-3204

Sarabob Londeree 69
1084 Grove Park Drive East
Orange Park, FL 32073

Wini Long 21
2938 Park Lake Drive
Bradenton, FL 34209

Richard K. Loud 137
P.O. Box One
Salem, MA 01970

Robert Lovett 136
19 Chauvel Court
Currumbin, Queensland 4223
Australia

Ward P. Mann 64
163 Stony Point Trail
Webster, NY 14580

Barbara W. Masters 84
47986 Waterview Drive
St. Inigoes, MD 20684

Victor Mays 110
38 Groveway
P.O. Box 207
Clinton, CT 06413

Jerry McClish 5
1011 51st Street East
Bradenton, FL 34203

Margaret S. McCrea 11
46 Hammond Street
Newport, RI 02840

Frank Milauskas 102
74 Wachusett Avenue
Arlington, MA 02174

Robert T. Miller, AWI, FVAS 42
Unit 187 Cumberland View
Whalley Drive
Wheelers Hill, Victoria 3150
Australia

Leonard Mizerek 120
35 Edgewater Hillside
Westport, CT 06880

Donald A. Mosher 16
13 Main Street
Rockport, MA 01966

Dutch Mostert 17
667 Mallard Lane
North Bend, OR 97459

William G. Muller 43
P.O. Box 425
260 Santuit Road
Cotuit, MA 02635

Ben Neill 18
88 Wood Avenue
Sandwich, MA 02563-1942

Thomas A. Nicholas, NA,
 AWS 36
7 Wildon Heights
Rockport, MA 01966

Paul Niemiec, Jr. 74
P.O. Box 674
Baldwinsville, NY 13027

Nathalie J. Nordstrand, AWS 38
384 Franklin Street
Reading, MA 01867

Donald O'Brien 77
P.O. Box 802
South Dennis, MA 02660

Yves Parent 50
P.O. Box 751
Old Saybrook, CT 06475

Wilma Parker 62
222 Clara Street
San Francisco, CA 94107

John Parkinson, FRAS,
 AWI 97
2/118 Hutton Road
Entrance North
New South Wales 2261
Australia

Lilian E. Parks 3, 71
Shadow Woods, Villa 7
600 Brandywine Road
Waynesville, NC 28786

Halsey R. Peterson 104
4051 58th Street North
St. Petersburg, FL 33709-6013

Natalie Pfanstiehl 67
11 Annandale Road
Newport, RI 02840-3610

Carlton Plummer 26
10 Monument Hill Road
Chelmsford, MA 01824

Dorothy J. Ramsey 47
49A Main Street
Rockport, MA 01966

Charles Raskob Robinson 19
Brush Hill Studios
88 Clark Road
Washington, CT 06793-1101

Steve Rogers, NWS 63
26 Sunset Boulevard
Ormond Beach, FL 32176

Herbert Rose 106
923 13th Street West
Bradenton, FL 34205

Jerry Rose 94
700 Southwest 31st Street
Palm City, FL 34990

A. William Rouzie 8
12426 Southwest 34th Avenue
Portland, OR 97219

Sandra Saitto 51
61 Carmel Lane
Feeding Hills, MA 01030

Doris Sampson 85
10 North 58th Avenue West
Duluth, MN 55807

Frank P. Saso 91
3163 San Mateo Street
Clearwater, FL 33759

Betty Lou Schlemm 31
11 Caleb's Lane
Rockport, MA 01966

Robert C. Semler, ASMA 40
3308 56th Terrace East
Bradenton, FL 34203-5226

William Shelton 58
732 Point Brown Avenue, Suite 136
Ocean Shores, WA 98569

Alan Simpson 20
24 Waltham Road
Bournemouth
Dorset BH7 6PE
England

John Sowers 25
3821 Lincoln Street
Hollywood, FL 33021

Michael Stoffa 122
49A Main Street
Rockport, MA 01966

Donald Stoltenberg 55
947 Satucket Road
Brewster, MA 02631

Paul Strisik, NA 75
89 Marmion Way
Rockport, MA 01966

Richard W. Sullivan 138
805 Forest Grove Road
Colonial Beach, VA 22443

Robert Tandecki 86
8620 164th Avenue East
Sumner, WA 98390

Kevin Taylor 114
741 Hampton Street
Brighton, Victoria 3186,
Australia

Anthony R. Thompson 12
168 Trappe Lane
Langhorne, PA 19047

Bruce Turner 139
4 Story Street
Rockport, MA 01966

Karen Carter Van Gamper 133
5085 Buckingham Place
Troy, MI 48098

Tony van Hasselt, AWS 49
P.O. Box 6039
Fernandina Beach, FL 32035

Charles Vickery 9
4533 Wolf Road
Western Springs, IL 60558

Armando B. Vilches 54
6987 Superior Street Circle
Sarasota, FL 34243

Peter Vincent 35
P.O. Box 776
Rockport, MA 01966

Robert A. Wade, ISMP, KA, FRSA, AWI 78
Dunoon
524 Burke Road
Camberwell, Victoria 3124
Australia

Judi Wagner 48
1563 Canterbury Lane
Fernandina Beach, FL 32034

Dean F. Waite 87
606 Lake Vista Drive
East Hampton, CT 06424

Sylvia Waters 52
P.O. Box 6478
Big Bear Lake, CA 92315

Stanley Wayman 32
1444 Allen Street
Mt. Pleasant, SC 29464

Elaine Wentworth 44
132 Central Street
Norwell, MA 02061-1306

Helen West 112
P.O. Box 1029
Yachats, OR 97498

C. Keith Whitelock 81
1902 East Clear Lake Drive
Salisbury, MD 21804

Capt. M. E. Casey Whitten 24
4180 S. E. Buoy Lane
Stuart, FL 34997-6911

Maxwell John Wilks 1, 73
514 Souter Street
Eltham
Melbourne, Victoria 3095
Australia

Joyce Williams, AWS, NWS 115
Box 192
Tenants Harbor, ME 04860

Dee Winterhalter 61
4027 Westbourne Circle
Sarasota, FL 34238

Madlyn-Ann C. Woolwich 125
473 Marvin Drive
Long Branch, NJ 07740

Karol B. Wyckoff 117
30 Fairway Road
South Yarmouth, MA 02664

Patricia Wygant 39
10 Winhurst Drive
Rochester, NY 14618